Published by The Friends of Photography, San Francisco in conjunction with the exhibition organized by The Friends of Photography.

EXHIBITION VENUES
August 14–October 20, 1996
Ansel Adams Center for Photography, San Francisco, Calif.

August 16–October 26, 1997
Williams College Museum of Art, Williamstown, Mass.

Steven Jenkins, Editor
Joanne K.H. Chan, Project Coordinator
Charlene Rule, Production Editor

Designed by Toki Design, San Francisco

James Casebere, "Three Stories," from *Blasted Allegories* (New York: The New Museum of Contemporary Art and MIT Press, 1987), pp. 58-60.

Library of Congress Catalog Card Number
96-084926

ISBN 0-933286-71-6

Printed in Hong Kong by C & C Printing Co., Ltd.

Distributed by D.A.P., New York

COVER: *Arcade*, 1995.

screen." Louis Marin, "Toward a Theory of Reading in the Visual Arts: Poussin's *The Arcadian Shepherds," The Reader in the Text*, Susan Suleiman and Inge Crosman, eds. (Princeton: Princeton University Press, 1980); as quoted in Craig Owens, *Beyond Recognition: Representation, Power, and Culture*, Scott Bryson, et. al., eds. (Berkeley, Los Angeles, Oxford: University of California Press, 1992), p. 103.

5 Walter Benjamin, "Surrealism: The Last Snapshot of the European Intelligentsia," in *Reflections*, trans. Edmund Jephcott (New York: Harcourt Brace Jovanovich, 1978), p. 183. For more on the central role of photography in Surrealist practice, see Rosalind Krauss, "The Photographic Conditions of Surrealism," in *The Originality of the Avant-Garde and Other Modernist Myths* (Cambridge, Mass. and London: MIT Press, 1985), pp. 87-118.

6 Hal Foster has related these Surrealist effects in Casebere's photographs to a simulacral form that allows them to act as therapeutic indexes of memories real and imagined: "The uncanny, of course, is a matter of psychic not material reality. Similarly, as Freud came to see, the memories related by analysands are often phantasmical, a *bricolage* of memories old and new, true and false. Yet such phantasms remain "therapeutically effective" without referring to a specific event. In other words the state recalled—whether a memory, a moment returned as uncanny, or even a "primal scene"—need not have actually existed. And so it is with Casebere's phantasms: they repeat scenes and events that, however familiar, remain absent and untold. Resonant with repetitions yet without originals, they are simulacra; not real yet somehow "effective," they are phantasms...they are uncanny." See Foster, "Uncanny Images," p. 204.

7 The short text is as follows: "In the second half of the twentieth century American children often had toys they played with and learned from. They went to school, did chores, grew up, left home to prove themselves, and sometimes made homes of their own. (These things try to go on forever.)" James Casebere, *In the Second Half of the Twentieth Century...* (Buffalo: CEPA Gallery, 1982), pp. 4-5.

8 Casebere, unpublished interview with Gregory Crewdson, n.p.

9 Casebere follows this ominous pairing with a section entitled "Mathematics"—an illustration of the madness of Pentagon expenditures. On the right-hand page, a chart reprinted from the *New York Times* converts the cost of standard military items into their civilian equivalents (two B1 bombers = $400 million = the cost of rebuilding Cleveland's water supply system); on the left, whitewashed models of military and civilian hardware playfully visualize the troubling equation. For the complete text, see Ibid., pp. 12-13.

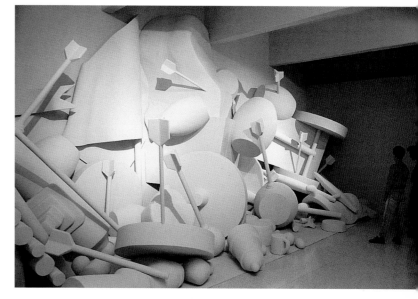

Western Corner Sculpture, Walker Art Center, Minn., 1987. Fiberglass and epoxy over mixed media, 30 x 11 x 6 ft. Collection of Neuberger Museum, SUNY Purchase.

10 Casebere, unpublished interview with Gregory Crewdson, n.p.

11 Casebere suggests that the dramatic increase in the prison population of the United States can be read as a symptom of an overall sense of crisis and frustration: "It is something we don't want to face, as if imprisoning people is the only thing we can do to exert power over a world spinning out of control." See Ibid.

12 Michel Foucault, *Discipline and Punish: The Birth of the Prison*, trans. Alan Sheridan (New York: Vintage Books, 1979), p. 228.

13 As Foucault writes of the panopticon: "[It] makes it possible to draw upon differences: among patients, to observe the symptoms of each individual, without the proximity of beds, the circulation of miasmas, the effects of contagion confusing the clinical tables; among school children, it makes it possible to observe performances (without there being any imitation or copying), to map attitudes, to assess characters, to draw up rigorous classifications and, in relation to normal development, to distinguish "laziness and stubbornness" from "incurable imbecility"; among workers, it makes it possible to note the aptitudes of each worker, compare the time it takes to perform a task, and, if they are paid by the day, to calculate their wages." See, Ibid. p. 203.

14 Ibid., p. 202.

15 James Casebere and Gregory Crewdson, "The Jim & Greg Show" (interview), *Blind Spot*, (Issue 2, Fall 1993), n.p.

16 Foster, "Uncanny Images," pp. 202-203.

17 See Maurice Berger, *Labyrinths: Robert Morris, Minimalism, and the 1960s* (New York: Harper & Row, 1989), pp. 129-162.

18 "The Jim & Greg Show," n.p. For more on Minimalism and the modern social order, see Berger, *Labyrinths*, pp. 129-162.

PORTFOLIO

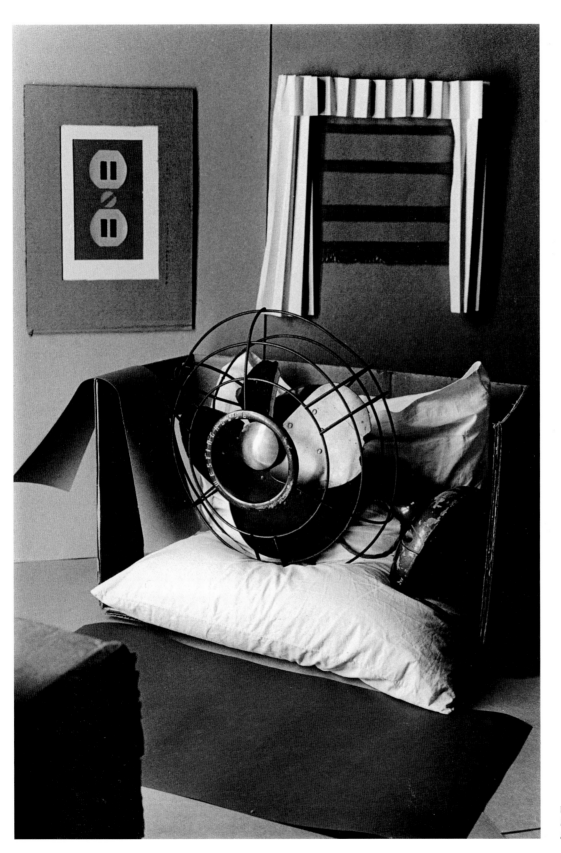

P L A T E 5
*Fan as a Eudemonist: Relaxing after
an Exhausting Day at the Beach*, 1975.

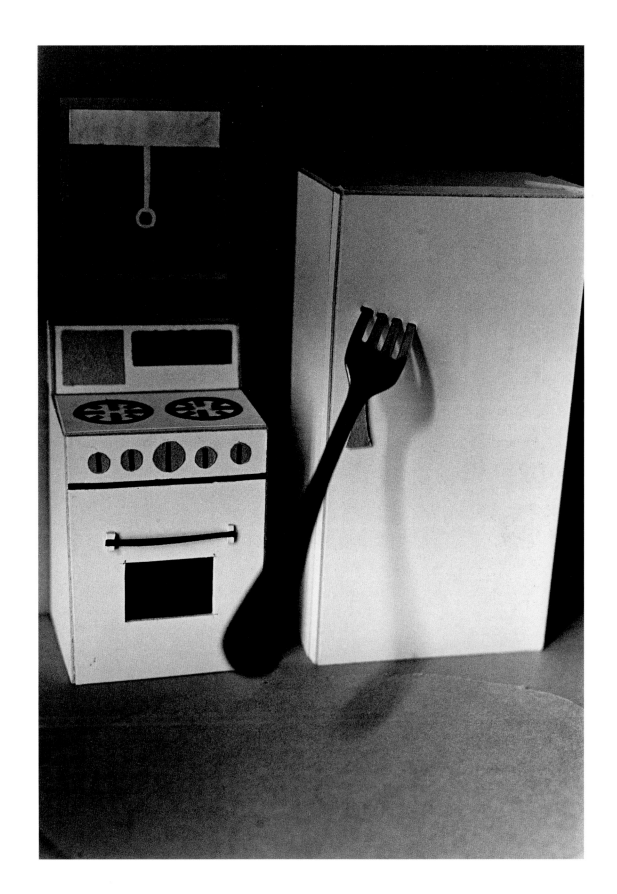

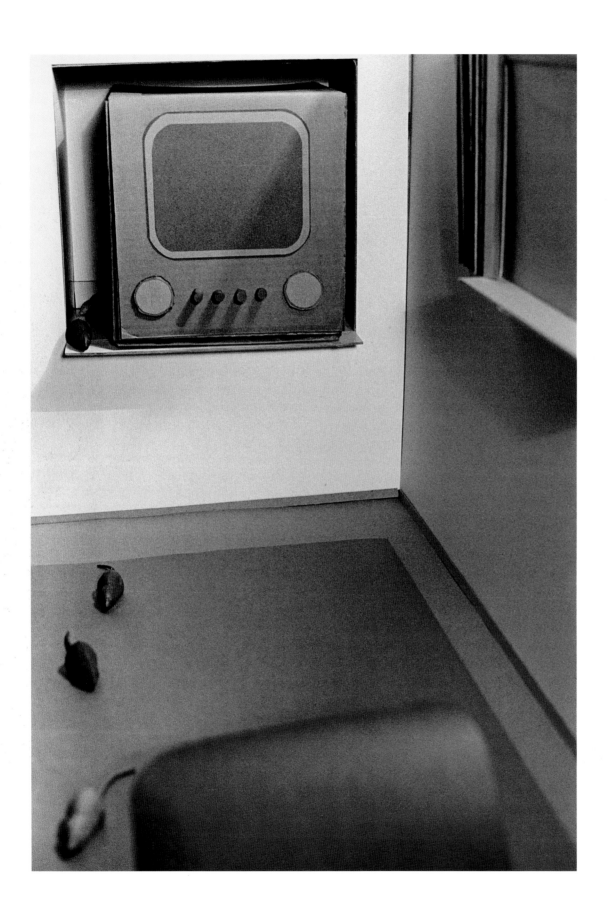

Bed Upturning its Belly, 1976.

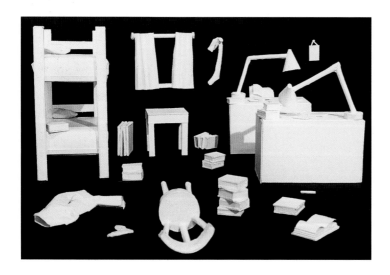

Top:
PLATE 9
Life Story Number One, Part 1, 1978.

Center:
PLATE 10
Life Story Number One, Part 2, 1978.

Left:
PLATE 11
Life Story Number One, Part 3, 1978.

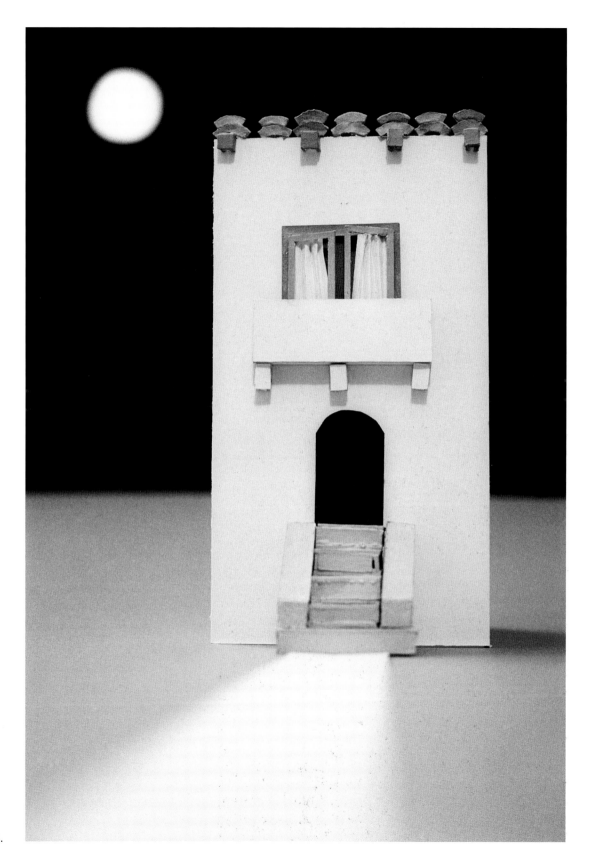

PLATE 12
Life Story Number One, Part 4, 1978.

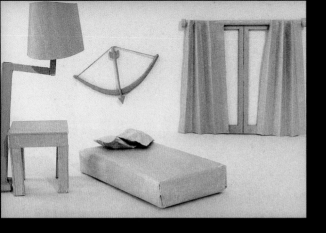

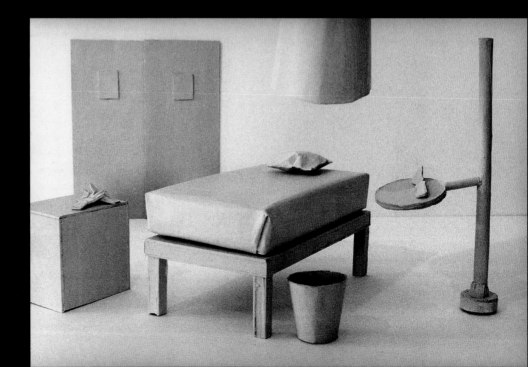

Top:
PLATE 13
Life Story Number One, Part 5, 1978.

Right:
PLATE 14
Life Story Number One, Part 6, 1978.

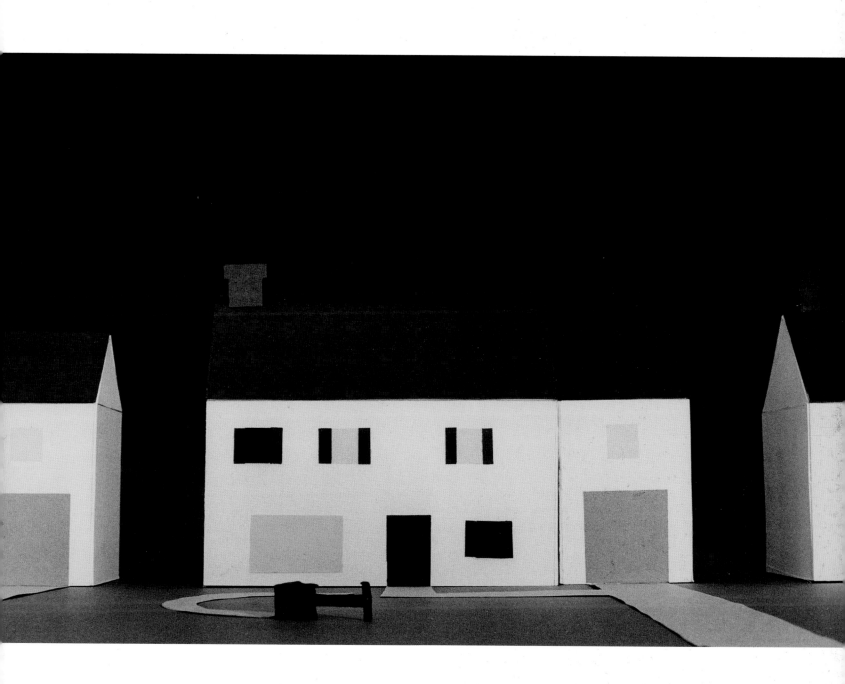

PLATE 15
Life Story Number One, Part 7, 1978.

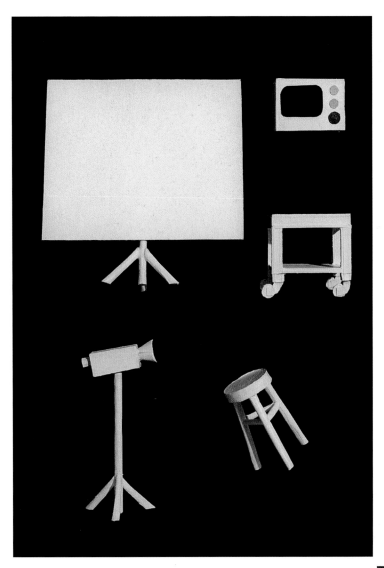

Top:
PLATE 16
Life Story Number One, Part 8, 1978.

Right:
PLATE 17
Life Story Number One, Part 9, 1978.

Facing page:
PLATE 18
Life Story Number One, Part 10, 1978.

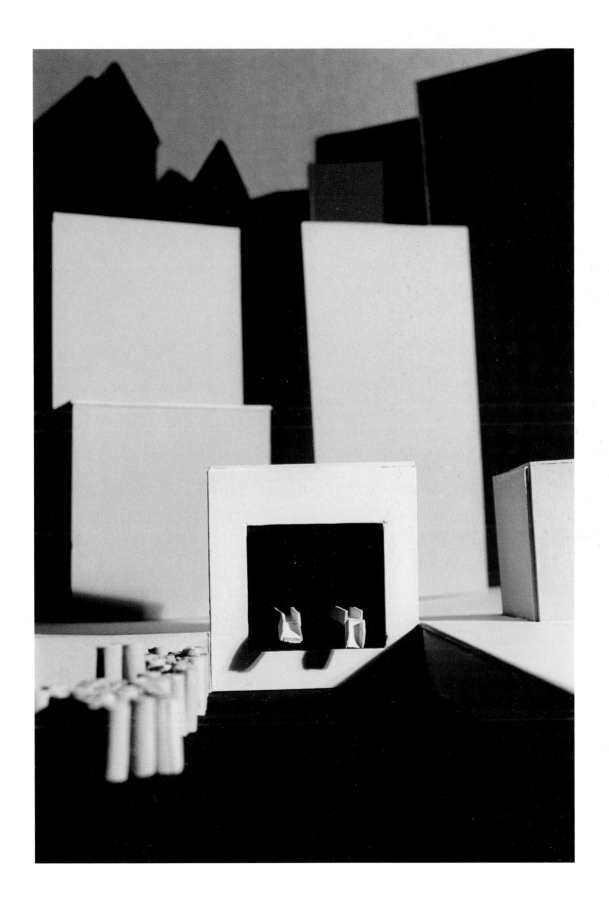

being affected

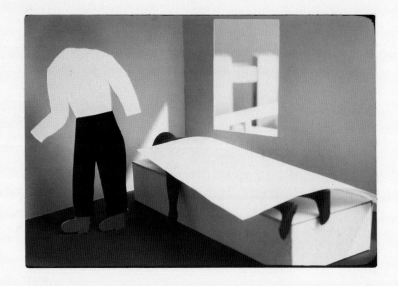

conscious / consciousness

absence

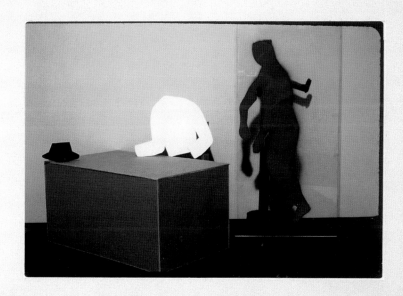

unconsciousness / unconscious

PLATE 23
Desert House with Cactus, 1980.

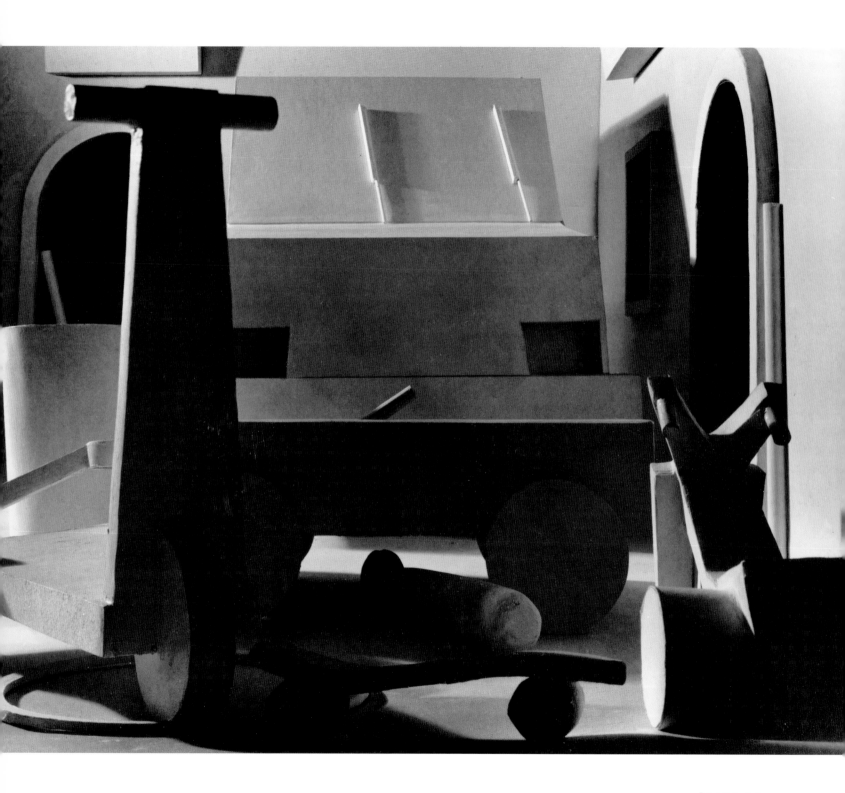

PLATE 25
Driveway III, 1981.

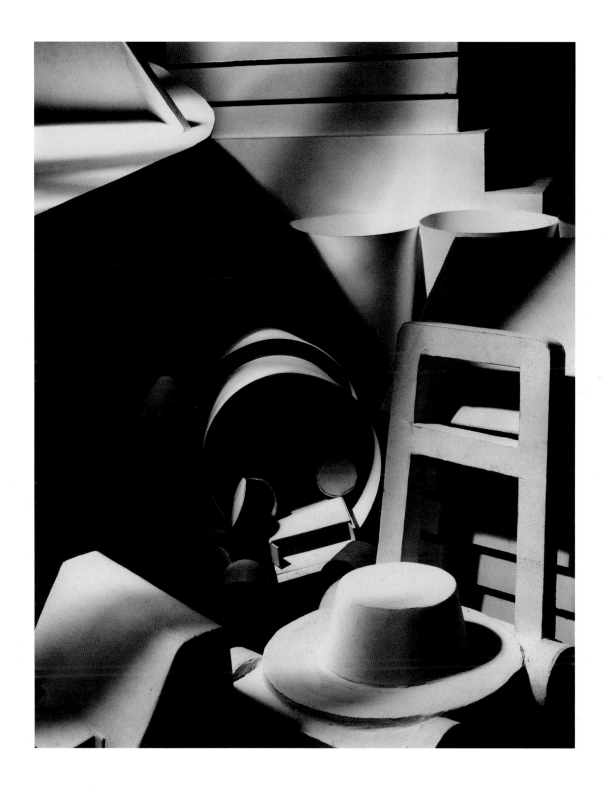

PLATE 26
Back Porch II, 1982.

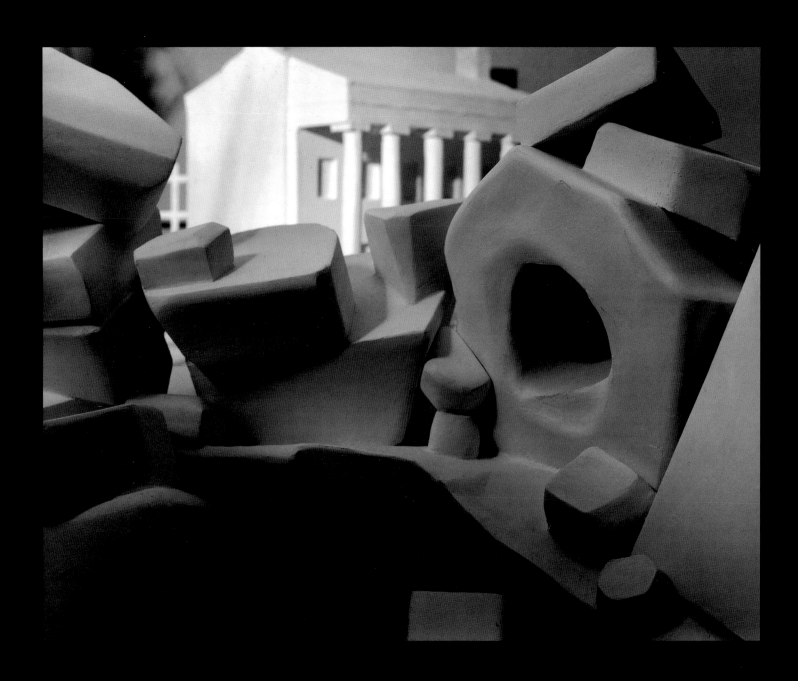

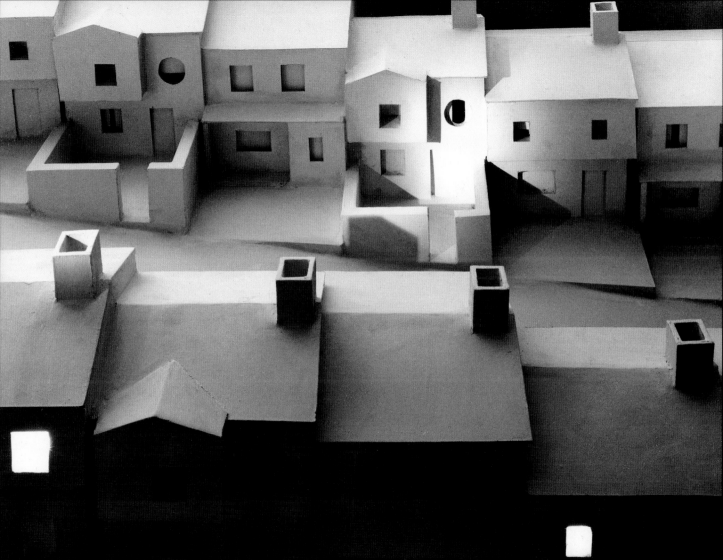

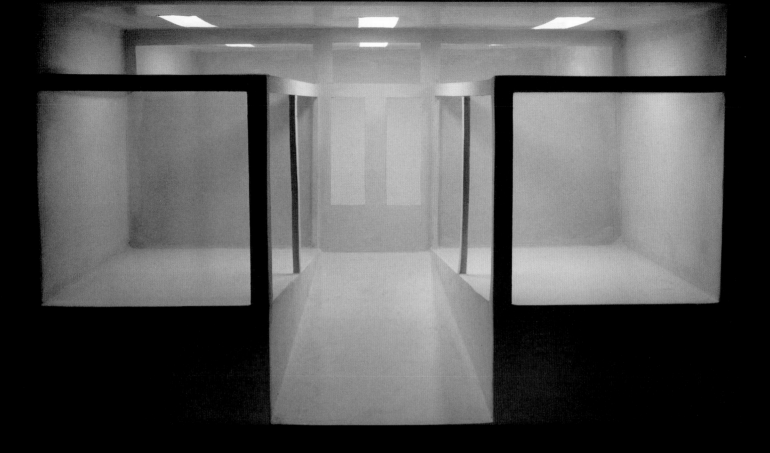

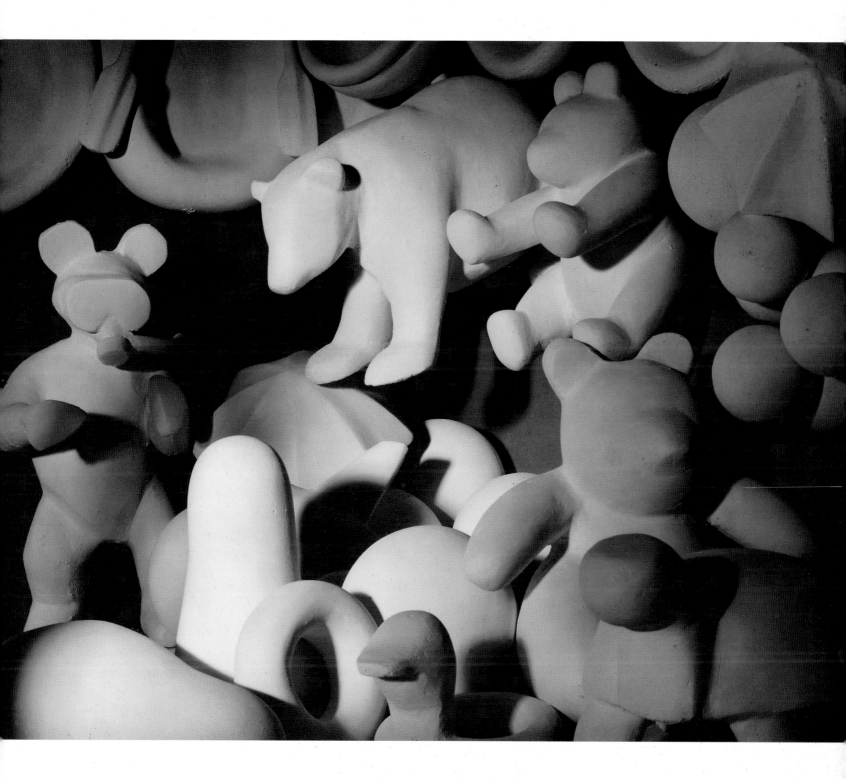

PLATE 30
Watertoys, 1982.

PLATE 31
Waterfall, 1983.

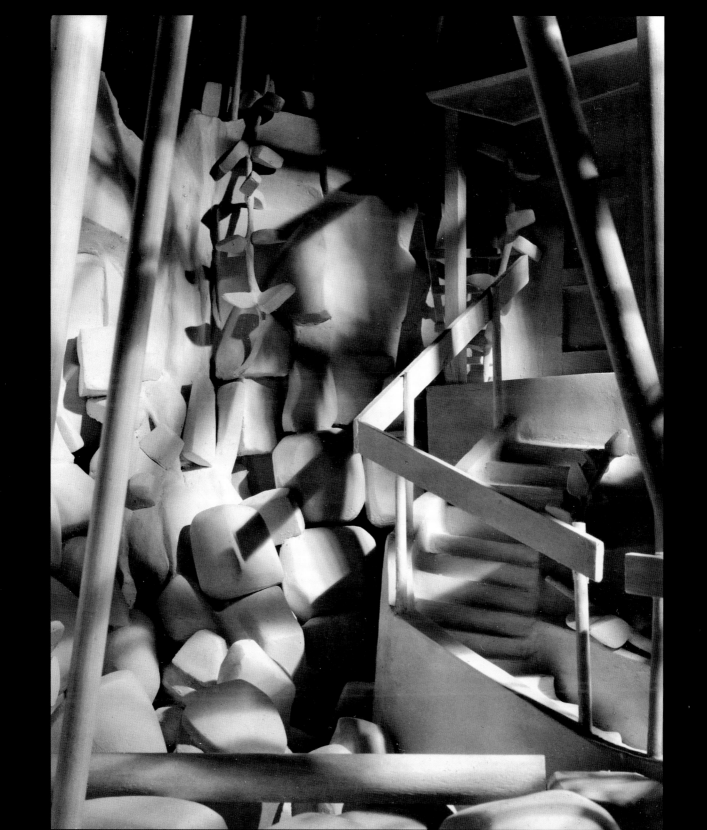

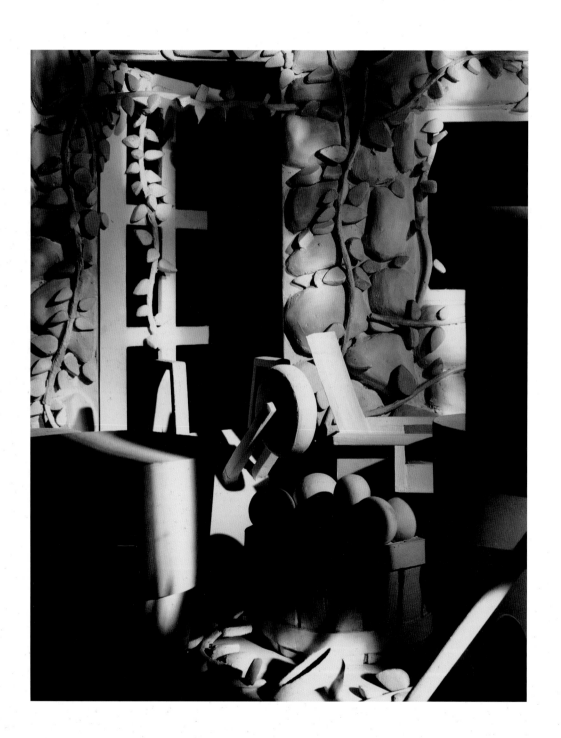

PLATE 32
Stonehouse, 1983.

Facing page:
PLATE 33
Cotton Mill, 1983.

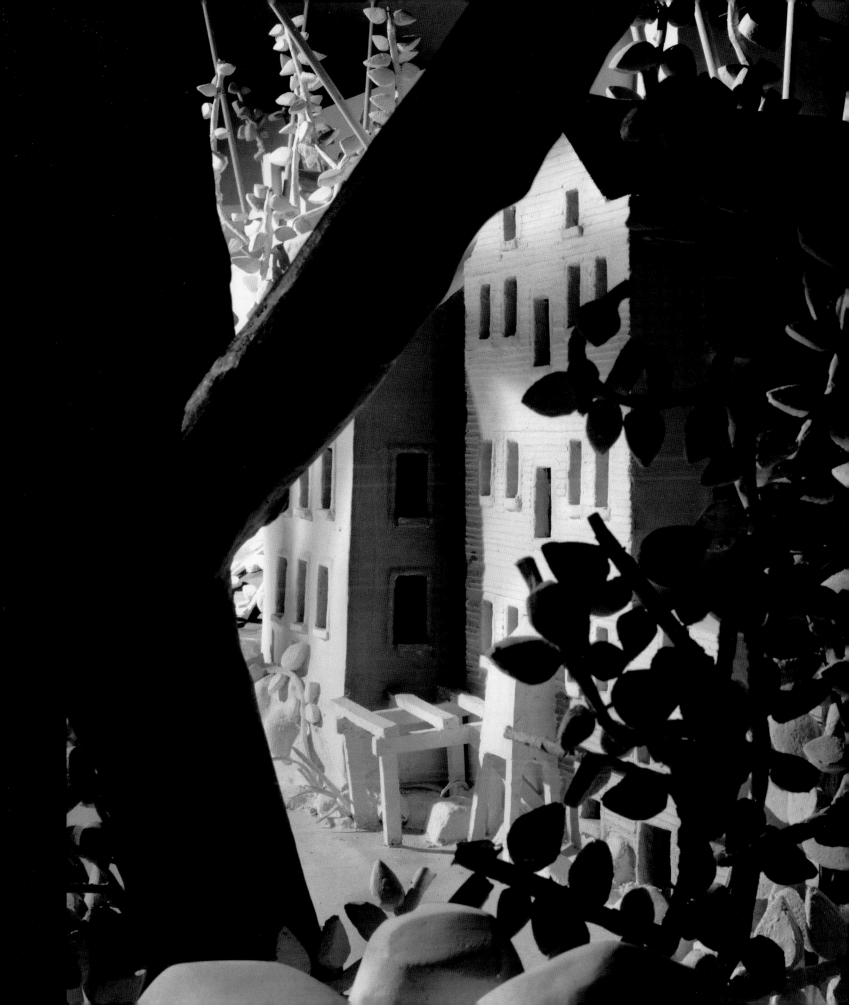

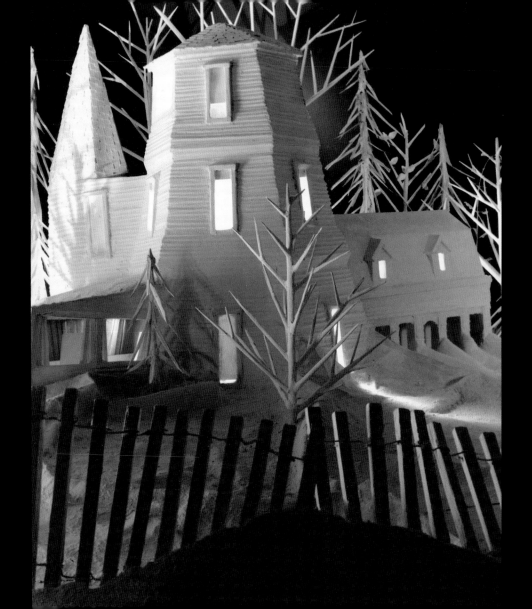

PLATE 34
Winterhouse, 1984

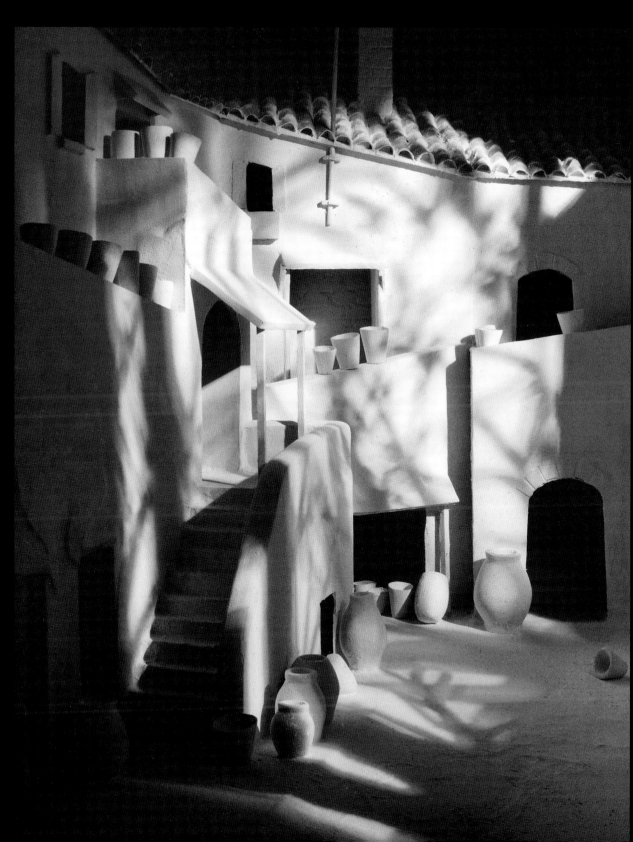

PLATE 35
Street with Pots, 1983

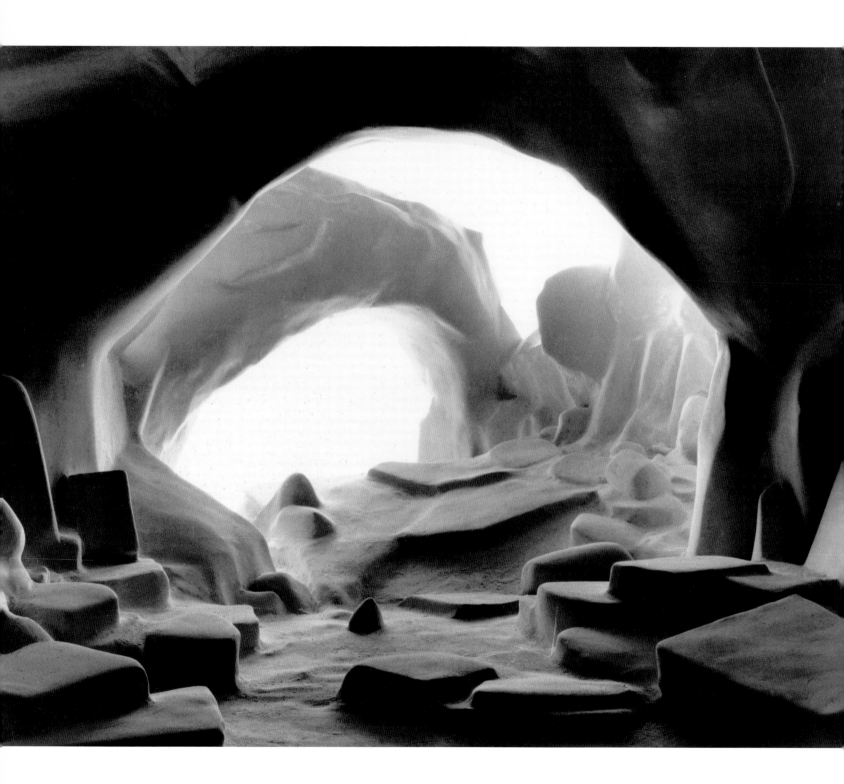

PLATE 36
Arches, 1985.

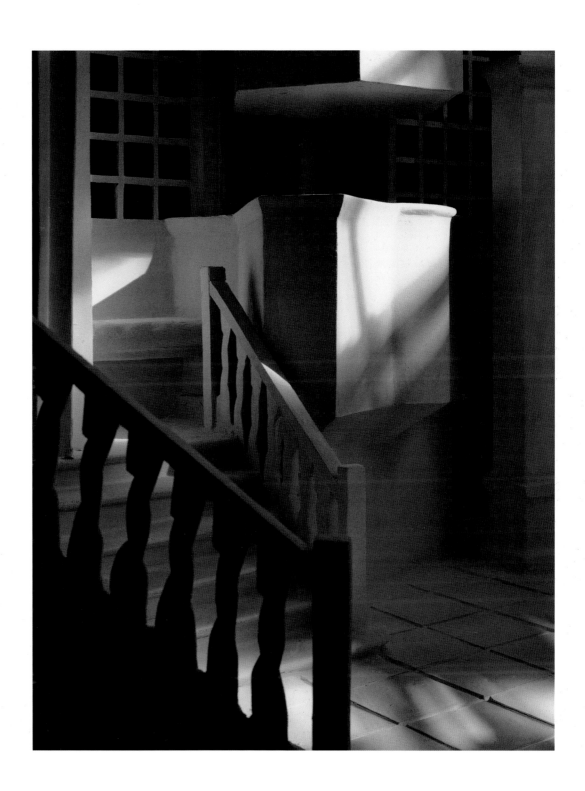

PLATE 37
Pulpit, 1985.

THREE STORIES

James Casebere

I. Horseback

From Chaos to Calm Going down the road, hot under the collar, steaming in your seat, bursting at the seams, ready to kill. Get in my way and I'll cut your throat, I'll break your neck, I've had it, it's over, I can't take any more. You're losing grip, losing hold, losing that sense of direction. It's too hot, you get up and you're turning so fast, whirling so fast, little atom bomb, little dusty storm, so dry, settle down, settle to the ground. You move so fast, you need water, something to drink, water, yes, that's good, yes, now sit down.

Later It's like your skin is gone, you feel something cool, it must be rain, but you're still asleep, or are you? Yes, it's rain and it's falling but it's no relief and you dream, feel, imagine, sense that the flesh on your scalp is gone, and so is the bone. The drops of rain strike like acid, but you can't feel a thing.

Needles The Needles make up one long, horizontal image of strange phallic shapes, reaching up at the sky, irregular, asymmetrical, rugged, eerie, smooth. The outside and in have become interchangeable. The distance, the illegibility of the forms: look down someone's throat, it looks like a cave.

The Great Mystery The great mystery is change. It's the movement from one moment to the next, the relativity of truth, the illusion of total obsession. It is the peculiar logic of human motivation, the immersion in a self whose boundaries are like scabs to be picked; sensitive scabs, painful to the touch, getting bumped, starting slowly to heal.

The Red River Trail Previously propelled by inner pain, it surrounds you now, waiting to engulf you. You don't know where you belong, you keep moving, shifting, not settling. You could go up the wrong canyon and be killed. What if you could leave your body, levitate up and look down, see the mess you're in and see the way out?

The Road West Moving west on the Chisholm Trail. The road west was the trail of men looking for one more adventure after the next. One more sight to see, one more little conquest. Don't stop, keep it rolling, over mountains and fields, crossing rivers, mudflats, and sun-parched desert plateaus. The ultimate obstacle course, with wild Indians on every side, rattlesnakes under every rock, and ahead of you nothing but the great frontier. For the adventurous, stopping could only be one great disappointment. Stopping meant stopping time. It could mean an end to conquest and an end to change.

But, all across the continent, men would finally grow tired and, in an effort to stop time, they built the West. So, above all, when these men stopped, they built Empires. Everywhere they went, they'd stake a claim and erect their own little Imperial Domain, extending themselves into a realm beyond change, a realm of total control. "No more Indians, please, I've had enough." They made themselves secure.

Darkness So, there you are, beat. It's dark now, the crickets are chirping. There's a dry wind blowing in from the East. The back of your throat feels like fine sandpaper rubbing against your tongue. Sandman, stay away, I've got to stay awake. You dip your finger in the pot of coffee, thick like molasses, rub it against your teeth, then suck it clean. You want to scream. The fire rises in the wind. You shiver. Your stomach turns. It turns again. A little more, again and again, and again. You gather some dry earth, cupped in your hands, and let it fall fast, in a mess at your feet as you pull away.

II. SNAKE

You'd been moving at night now to avoid the heat or being spotted by either hostiles or army patrols. Your scalp, being worth more to a white man in gold than a renegade in prestige, was something you had hoped to keep. At least the white man would kill you first (of course, this could involve being dragged behind his horse by a rope for a mile or two first), then take his knife to your skull above the ear and, cutting a circle round your head, give it a good yank. The fact is no one likes to get skinned alive or cut up into half a dozen or so pieces. (Which was also likely with the redskins if you failed to put up a good fight.) So, the idea was not to get seen or taken alive. Knowing one foe to be more skilled and the other more determined, you could only slither along on your belly at night, and hide between the rocks to sleep by day.

III. HELL

This particular town didn't really belong here at all. Speculators, hoping for the railroad, put it up one day and the train never came. It went clear through to the northern pass, never sending a spur south at all. So, the goldminers (what was left of them) came to get their supplies, the cattle ranchers too, and the Pony Express galloped by two days a week.

But the town remained because no one had the energy or money to tear it down or burn it. It was a lucky traveler who left on his own two feet. Most ended up, oh, maybe three feet underground in an unmarked grave.

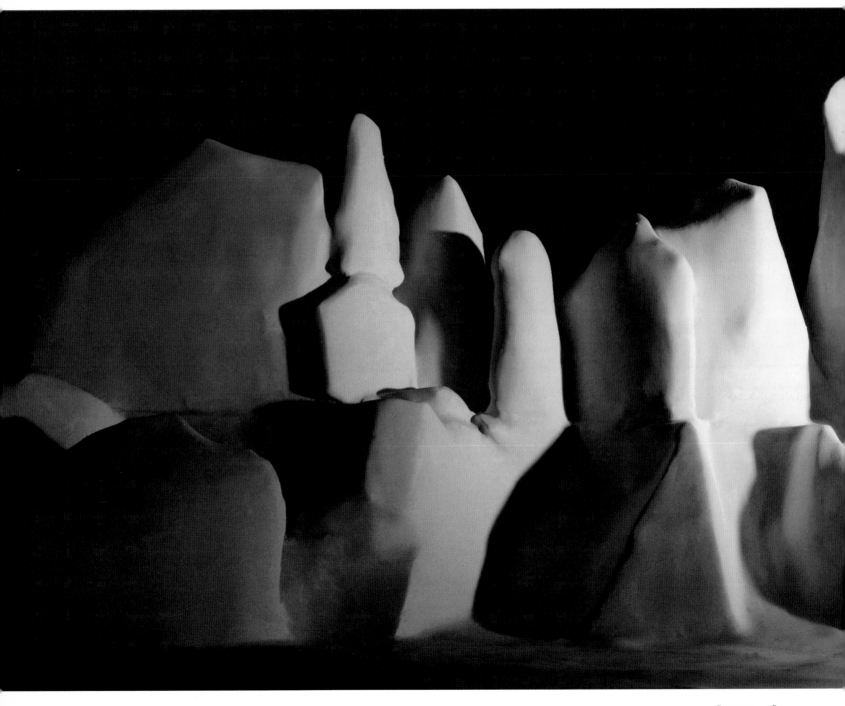

PLATE 38
Needles, 1985.

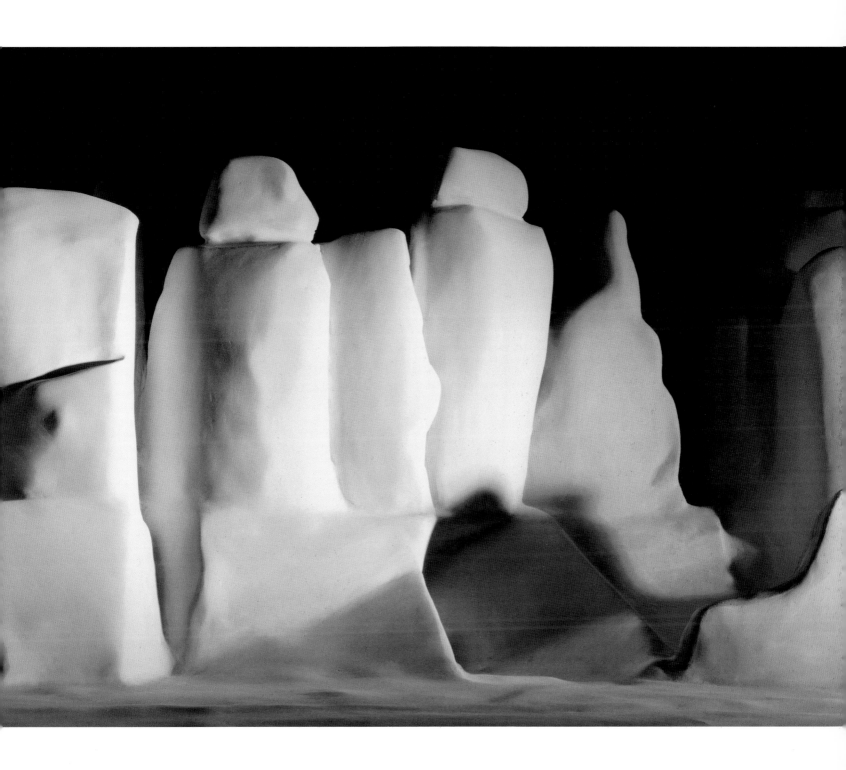

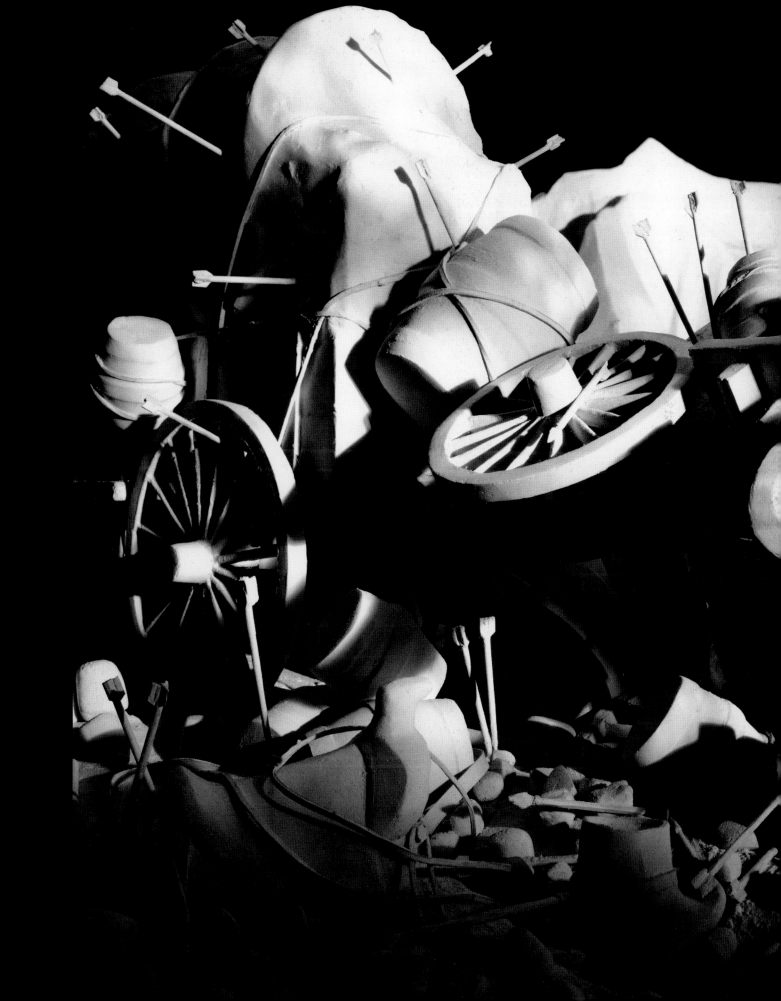

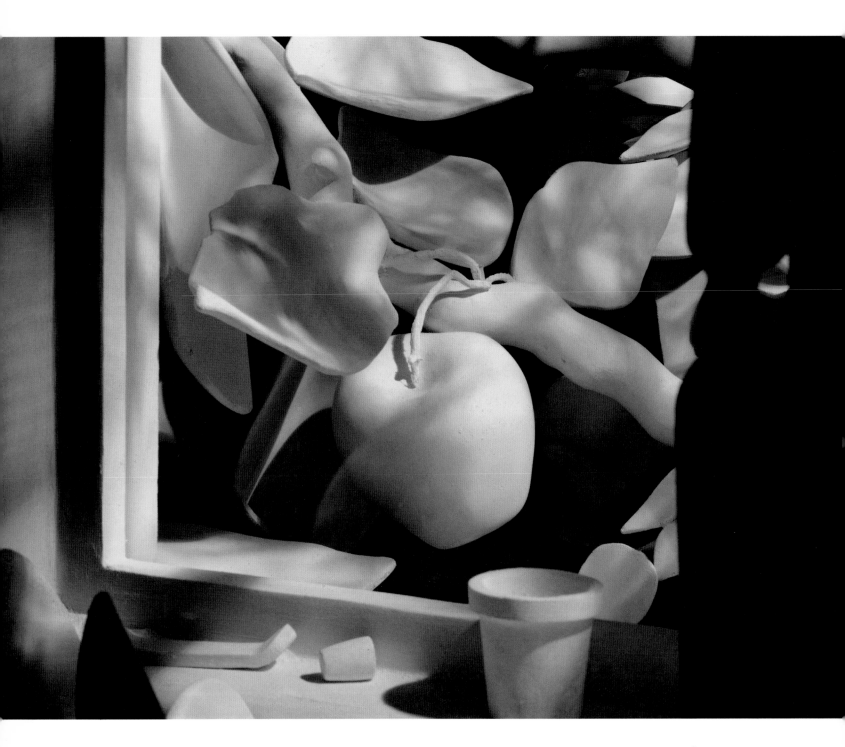

PLATE 40
Golden Apple, 1986.

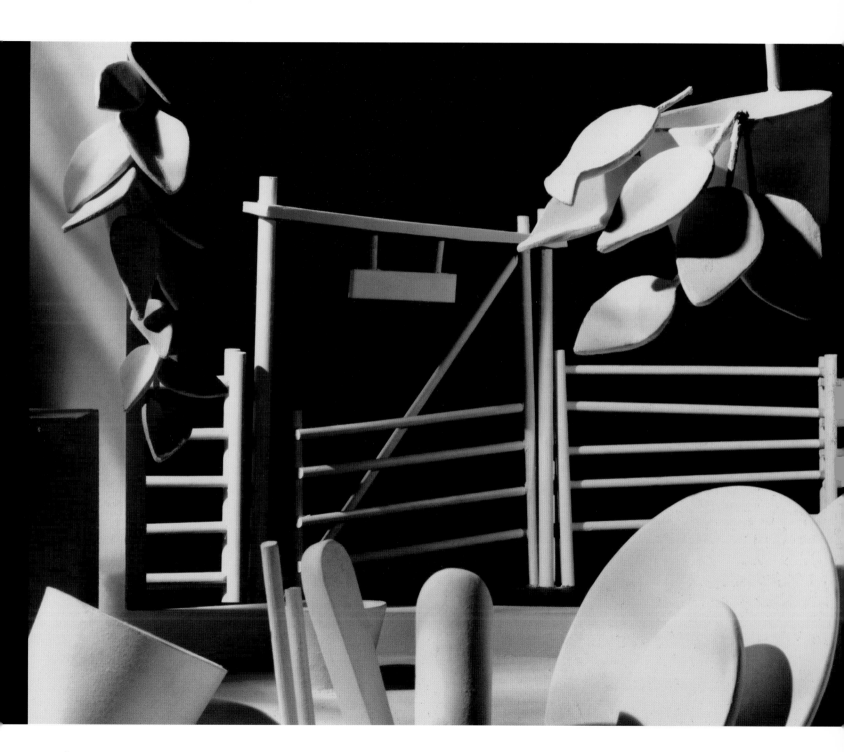

PLATE 41
Kitchen Window with Corral, 1987.

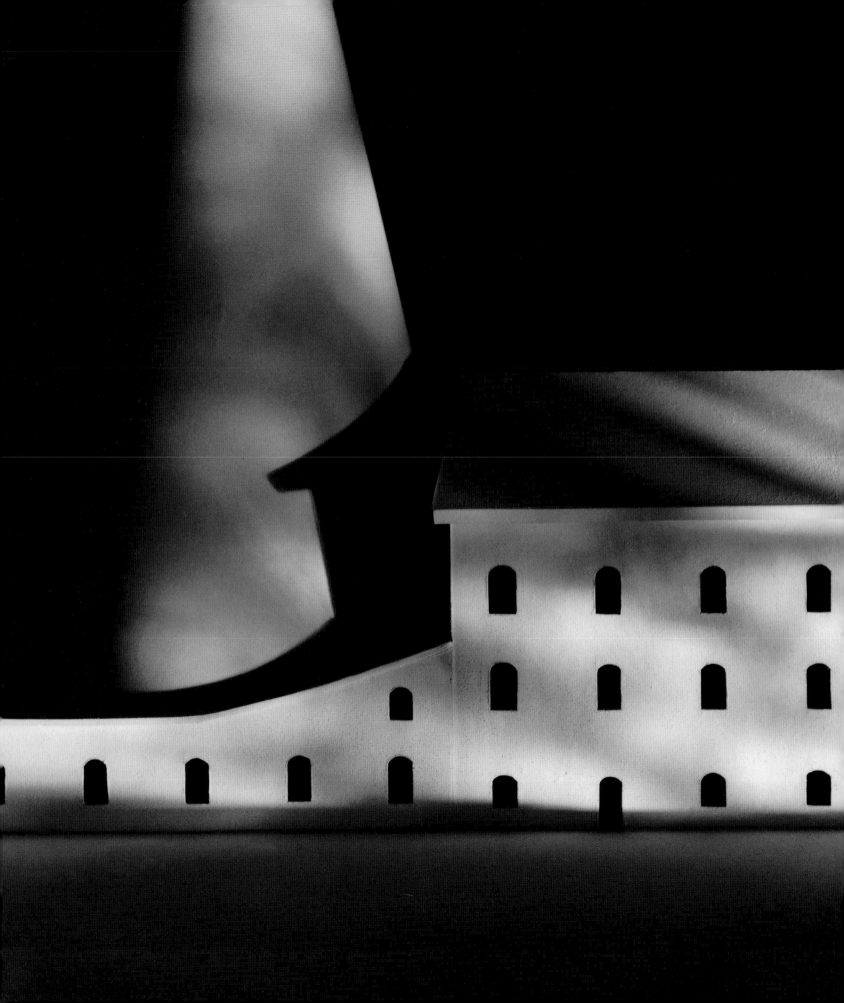

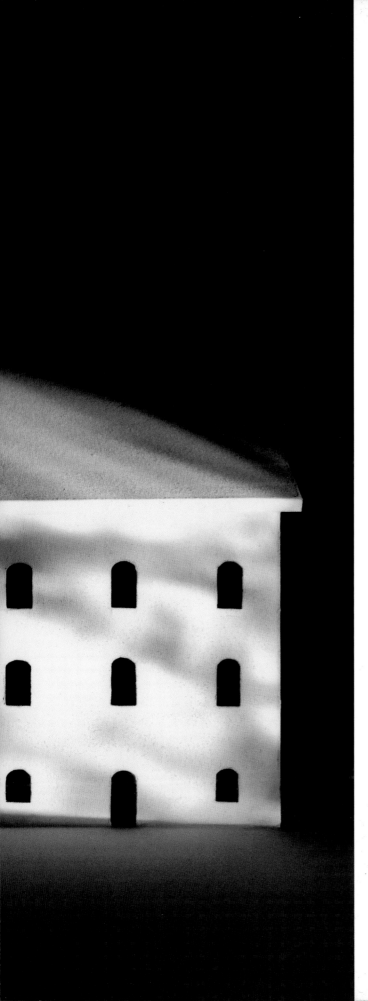

PLATE 42
Industry, 1990.

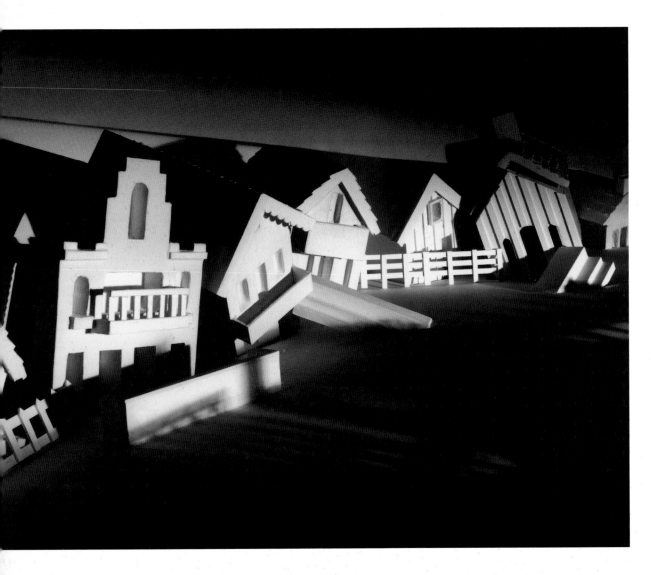

PLATE 43
Portuguese Beachfront, 1990.

Facing page:
PLATE 44
Venice Ghetto, 1991.

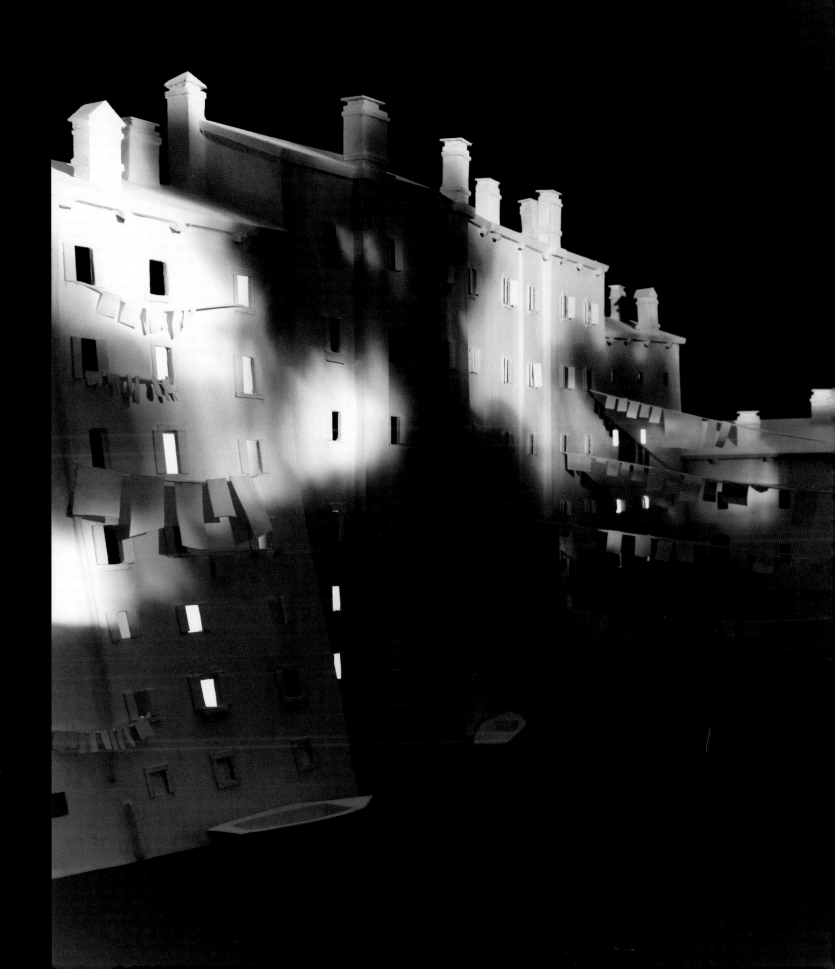

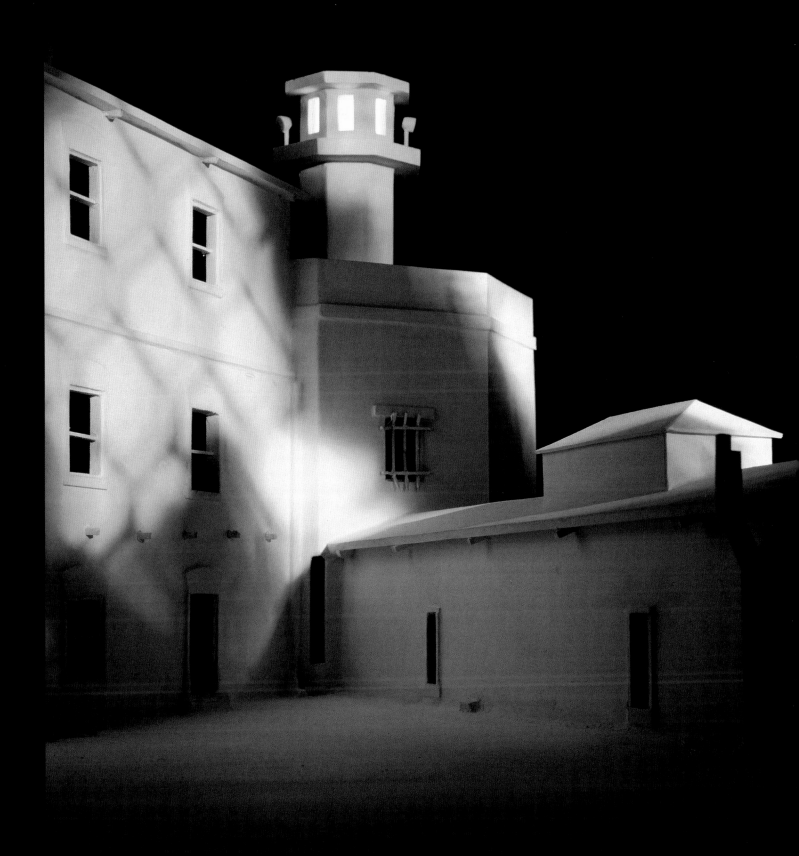

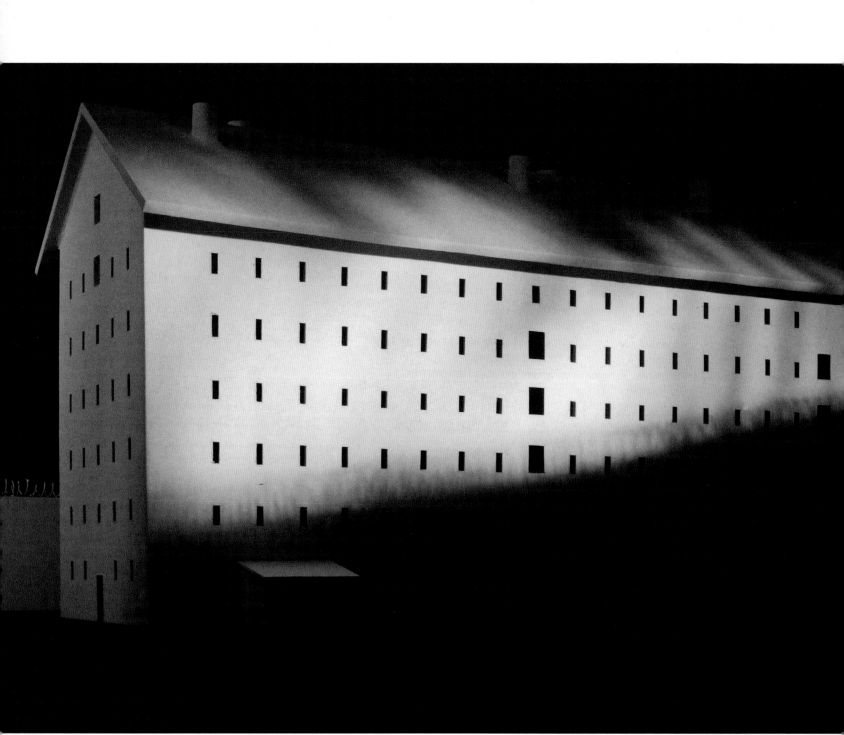

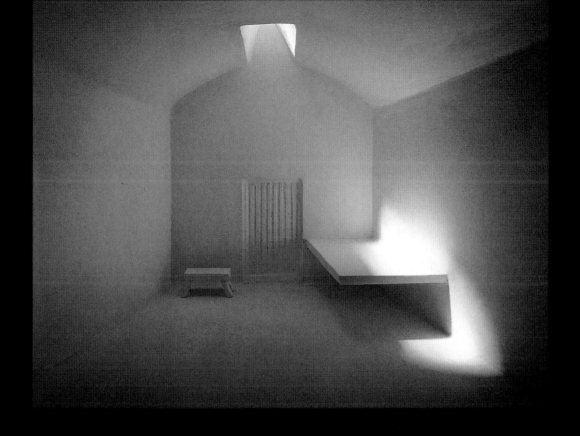

Facing page:

PLATE 46
Sing Sing #2, 1992.

PLATE 47
Prison Cell with Skylight, 1993.

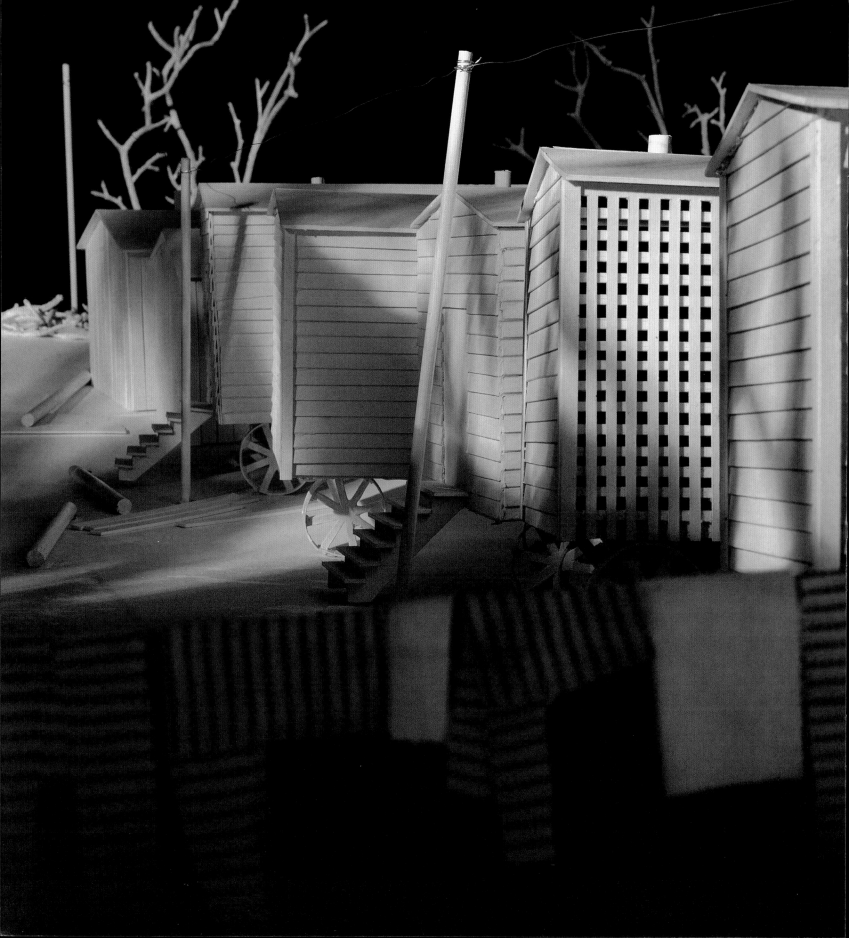

PLATE 48
Georgian Jail Cages, 1993.

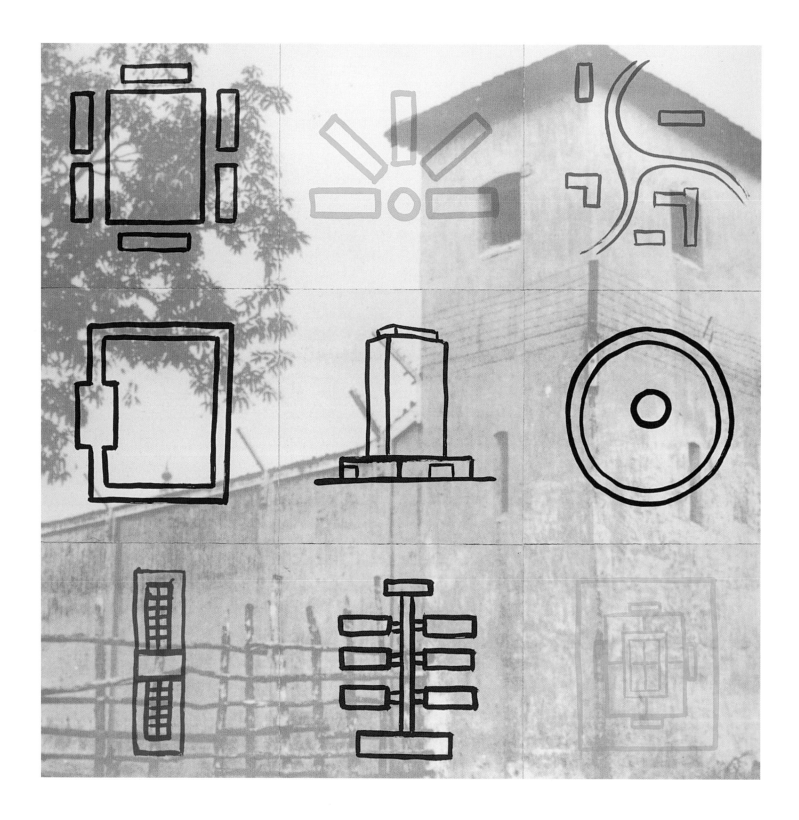

PLATE 49
Prison Typology in Nine Parts, 1993.

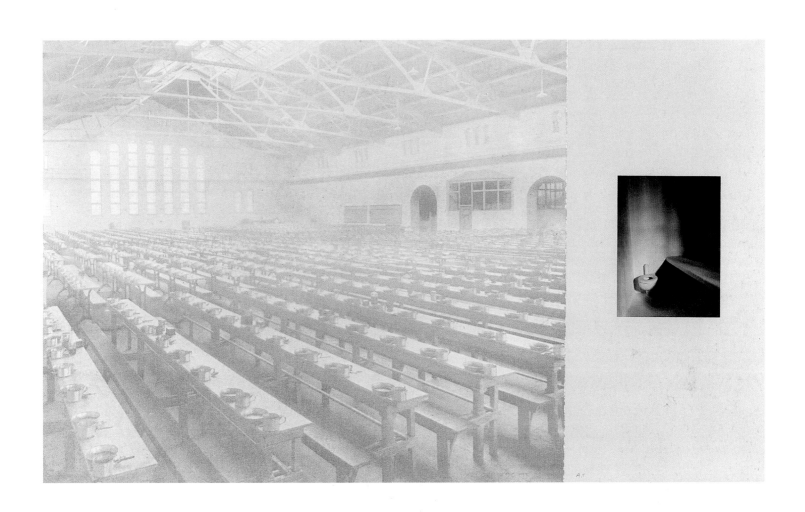

PLATE 50
Cafeteria and Cell with Toilet, 1993.

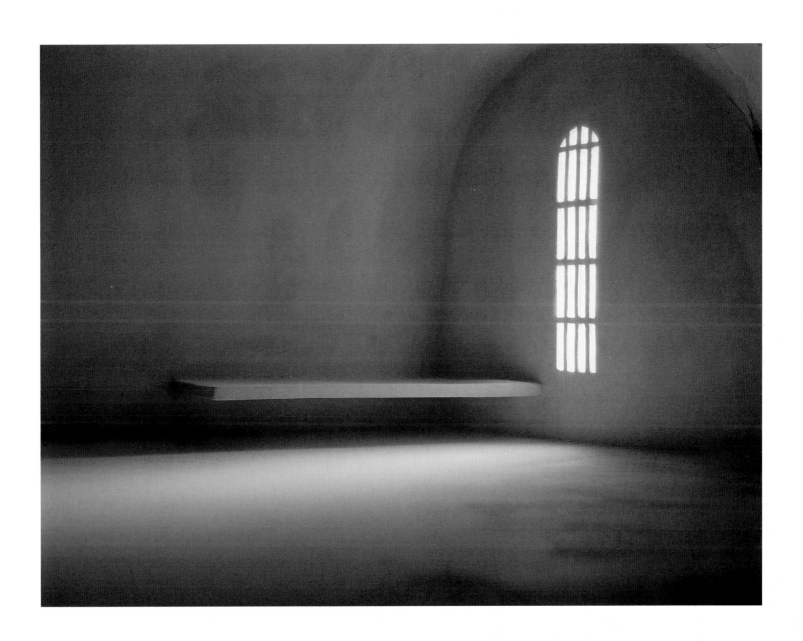

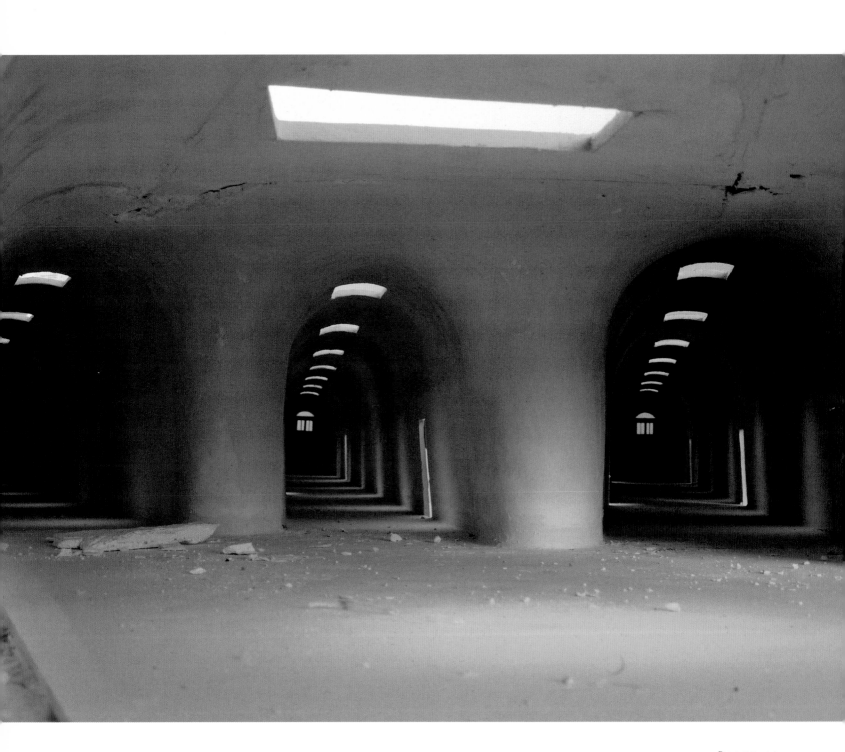

PLATE 52
Tunnels, 1995.

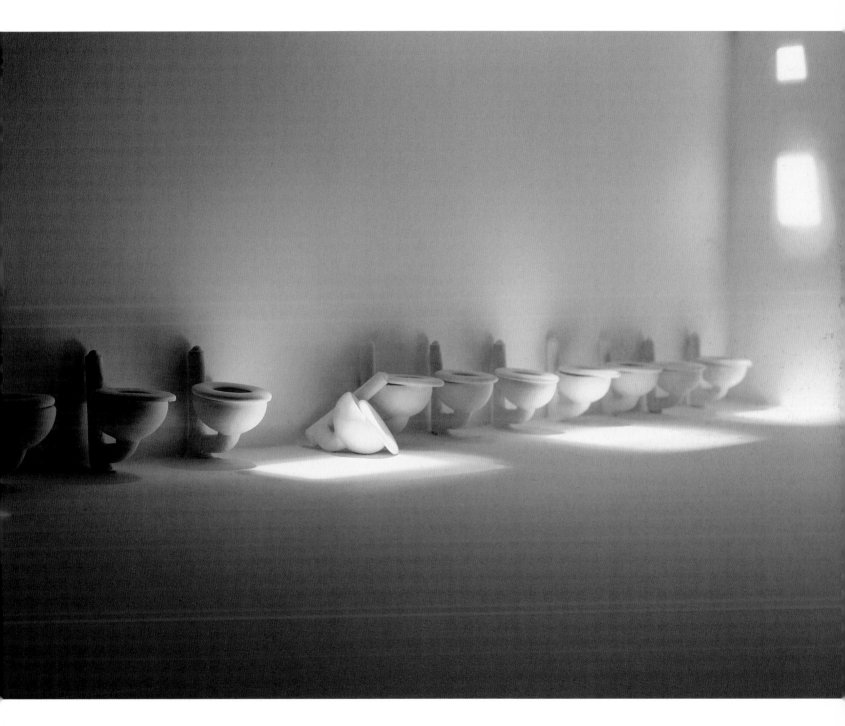

PLATE 53
Toilets, 1995.

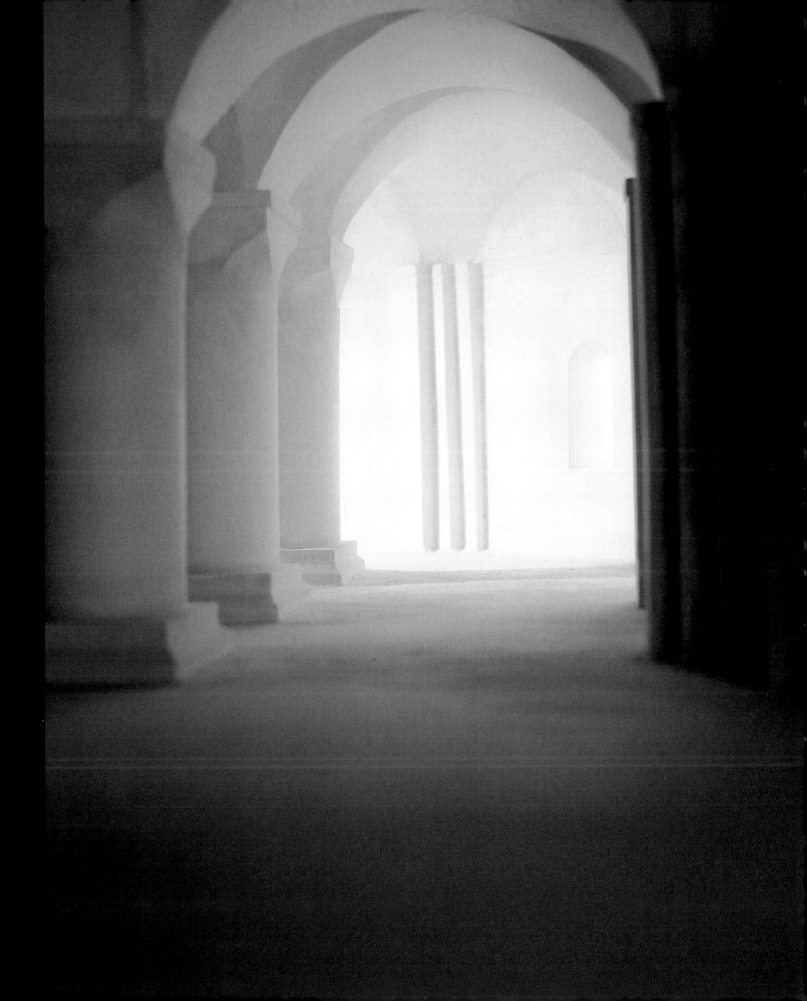

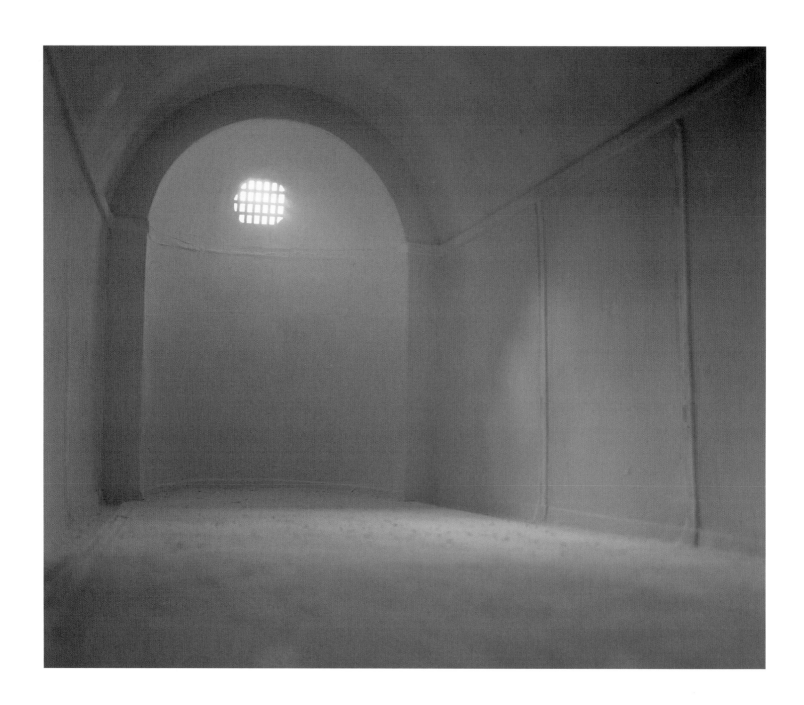

PLATE 55
Apse, 1996.

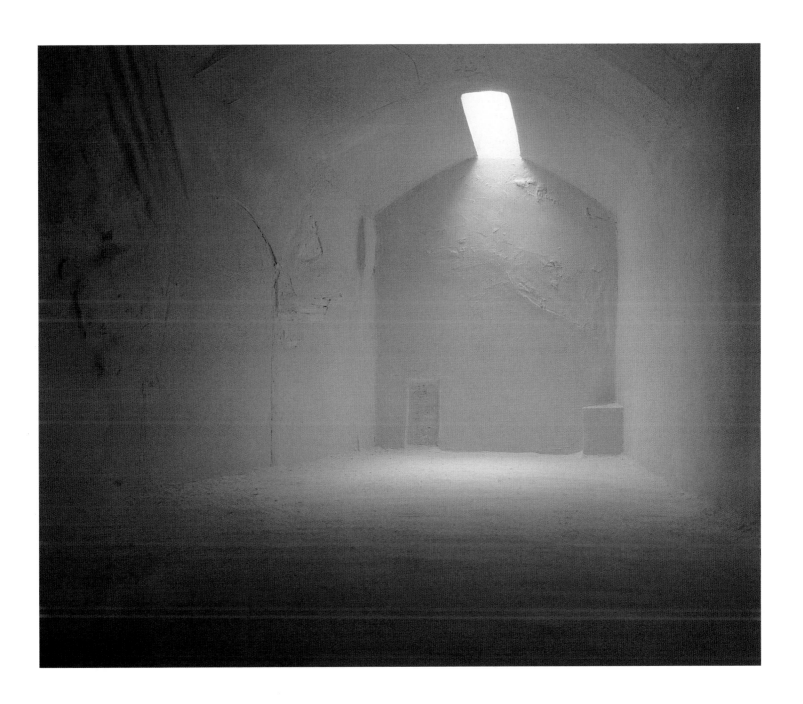

PLATE 56
Cell with Rubble, 1996.

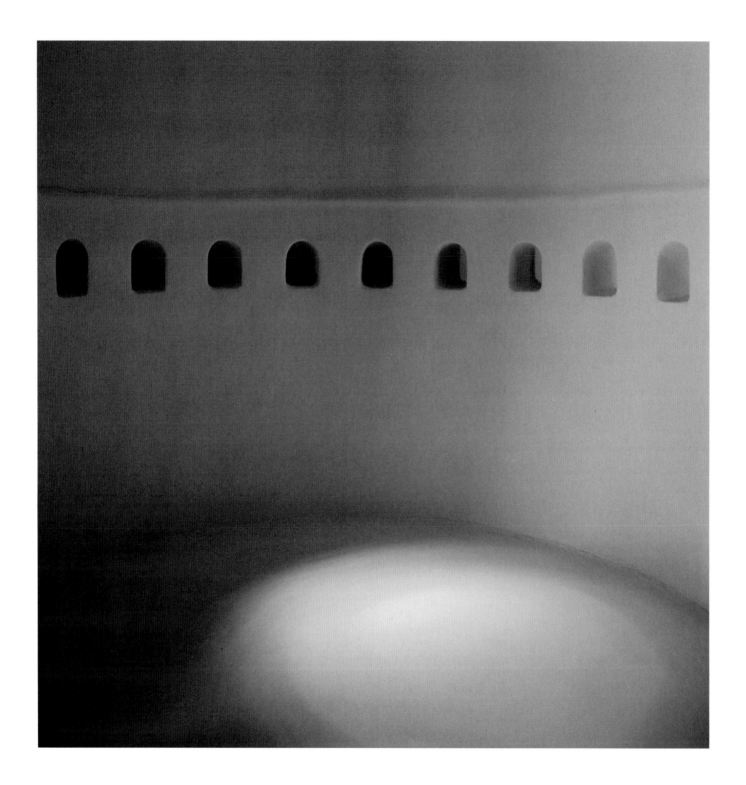

PLATE 57
Nine Alcoves, 1995.

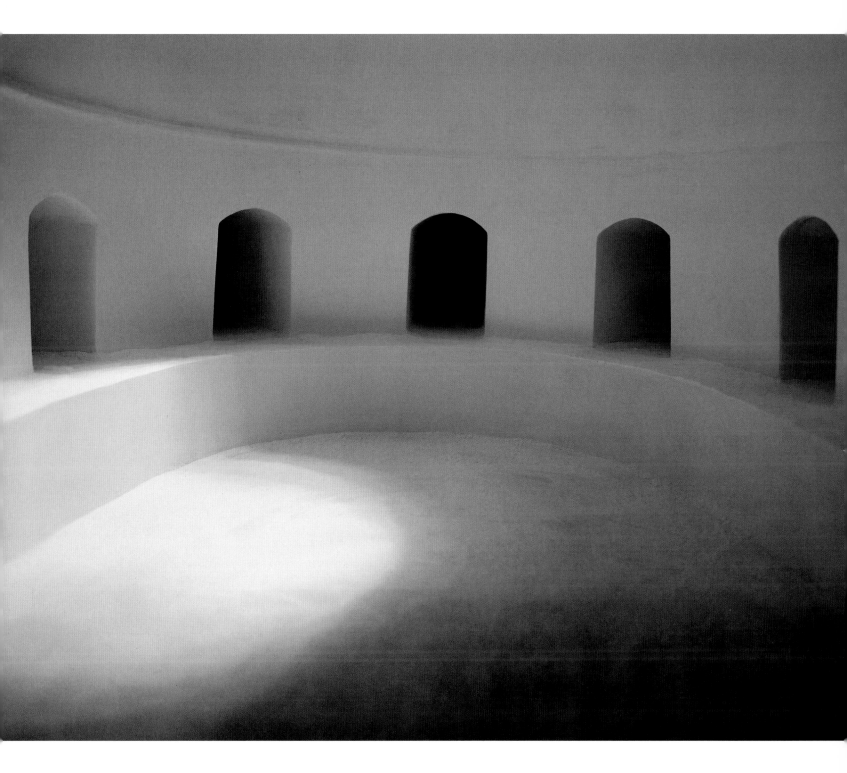

PLATE 58
Arena, 1995.

A CONVERSATION WITH JAMES CASEBERE

STEVEN JENKINS: *First of all, can you explain the nuts and bolts of your technique? What materials have you used over the years to construct the sets and models that you photograph?*

JAMES CASEBERE: When I began making the models they were much simpler than they are now. I used paper, cardboard, a few real objects and that's about it. Now, most everything I photograph is table-top size, varying from about 24 inches squared to 8 by 10 feet. I work with paper, mat board, foam board, cardboard, Styrofoam and plaster. The models are not very interesting in themselves. It's only when they're transformed through lighting and take on all the associations and illusions that photographs produce that they come alive. The room-size installations that I've done over the years, on the other hand, are built for specific spaces and are meant to be experienced by viewers as larger-than-life sculpture. The photographs I make of these installations are simply documents.

SJ: *How long do you work on each model?*

JC: It can vary from a few days to a few months. The amount of time has more to do with when I feel the model is resolved than with how much labor it actually requires.

SJ: *It sounds as if you don't leave much to chance, and that the models and photographs are conceptualized in advance.*

JC: I used to plan out all of the pictures before actually making them, and I drew sketches of the models before building them. I still do that to some extent, but lately I'm leaving a bit more to chance, as with the prison hallways in disrepair. In the case of *Tunnels,* a huge chunk of the ceiling broke off while I was working on it. I don't always know what I want. I often just try things out "in camera," shooting lots of Polaroids as I go.

SJ: *The sketches look like storyboards that directors and cinematographers might make when planning a film, and as a result the photographs have a certain narrative quality. Have you been influenced by film, either in narrative construct or content?*

JC: Early on I made a short film and one film-related installation. For "Life Story," an early sequence of ten images, I was thinking about film editing and montage.

I also realize that I'm part of the first generation of artists raised on TV. One of my earliest images, *Bacillus Pestis,* is named after the Latin medical term for the plague. It's a picture of a television set in a built-in wall unit with a footrest in the foreground and little rubber mice running out from behind the TV. The image comes from a childhood memory of waking up early in the morning and watching cartoons with mice dancing around the room and on piano keys. I was confused about whether I actually had seen mice run across the room or whether I had fallen asleep and incorporated the cartoons into my dreams. It's an image that stuck with me.

When I started making photographs, the work addressed the way the baby-boom generation incorporates television into its unconscious; it's part of our visual library. As I continued shooting pictures, I was thinking about film theory, montage and editing, and filmmakers like Sergei Eisenstein and Jean-Luc Godard.

SJ: *Were you trying to replicate the montage of Eisenstein or the jumpcuts of Godard into a series of still images?*

JC: "Life Story" used a sequence of images to create a simple, mundane, epic narrative. During the early 1970s, photography was being used by performance artists, earth artists and sculptors to document temporary installations. With that in mind, when I started setting up pictures I would create little scenes to document. I wanted to exploit some of the conceptual-art qualities that I was interested in, but also to create more impact by making the photograph itself the primary experience. And I wanted to use conventional pictorial means to do it.

At the same time, I was increasingly interested in architecture and in the ideas of Robert Venturi. In *Learning from Las Vegas* and *Complexity and Contradiction in Architecture,* Venturi looked at architecture as a sign system. He celebrated what he called the "ugly and the ordinary," suggesting that richness can come from conventional

architecture. I also started to read Roland Barthes and Jean Piaget, and to think about structuralism and semiotics. I wanted to create my own language of images as they related to film, architecture and photography.

SJ: *What's interesting is that early on you chose to apply theories regarding architecture, photography and image construction to the "Life Story" series, which ostensibly seems very personal.*

JC: It wasn't intended to be about my own specific experiences. I was trying to generalize. It was about a shared cultural experience that I happened to be a part of.

SJ: *So more of a generic "life story"?*

JC: Exactly. A lot of the work addressed social relationships. At the same time, I began to think of the artist's studio as an exaggeration of the idea of the individual artist and his isolation from society, stemming from the Romantic idea of individual creativity. By making photos of models, I wanted to juxtapose the individual with the broader social dialogue—the dialogue of art. An image that illustrates this juxtaposition is *Library II,* in which the study carrels are isolated but surrounded by a shared social space. The posters that I produced and put up around New York City—and later the light-boxes that I installed around the city—engaged people in a public space, and addressed the polarity of the individual within a larger social sphere.

SJ: *Looking at your work from the early 1980s, particularly images like* Library II, Courtroom, Storefront *and* Pulpit, *I begin to think of these archetypal structures as existing side by side on some mythical, all-American Main Street, like out of Thornton Wilder. These are buildings that for decades were considered emblematic of the metropolis, when city planning was conceived in terms of fostering social and community order. That idea seems to have disappeared during the last thirty years or so. People still congregate in public places, but to a large extent the sense of community has been replaced with a series of random encounters among*

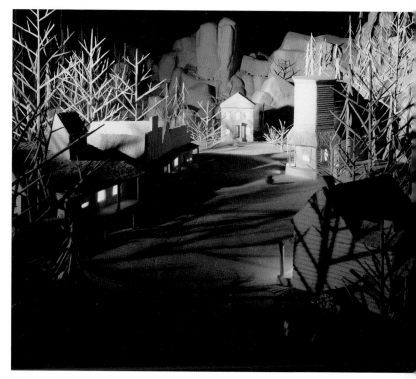

a bunch of strangers who wander around big cities. The idea of the community being defined by the public structures it creates has virtually vanished. A more brutal, less sympathetic architecture has a lot to do with that.

JC: Public, social spaces like town squares were built on a human scale. With urban renewal in the 1960s, narrow streets and tight ethnic communities were replaced by high-rise apartments or bisected by highways. Of course, today we have malls and concert halls that function as gathering places. In 1982, when I installed light-boxes at the Staten Island Ferry Terminal, I wanted to inject my own irrational images into the public context of advertising. Some of these images took the symbolic site of those ads—like the waterfall of the Kool cigarette ad, or the kitchen as a symbol of abundance and stability—and turned them on their heads.

I wanted to transform the mundane, familiar, domestic nature of contemporary life. In using generic things like a utility room or a back porch, or an overstuffed grocery bag filled with cereal boxes in a suburban kitchen, I wanted to create a field of insecurity with

images that were not easily explained or quickly resolved. I liked the idea of finding the extraordinary in the everyday. I was thinking in a dualistic way about humor and horror. Some of the first constructions referred to animation, and I wanted to emulate the way humor and misfortune were tied in the silent films of Buster Keaton and Charlie Chaplin.

SJ: *How did these interests segue into the Western images?*
JC: I was looking at the history of the suburbs that I felt so alienated from while growing up in the 1950s and '60s. I found their origins in the bungalow craze of the Arts and Crafts movement dating from the turn of the century to about 1920. The bungalow embodied certain social ideals: an affordable home for every family, on its own plot of land, in the middle of its own little Garden of Eden. That ideal was embodied in a sleeping porch that incorporated nature and fresh air into the home, and was linked to the mobility of the family car.

From there I began to think about Shingle-style architecture of the 1870s, the departure point both for Frank Lloyd Wright—the preeminent modern American architect—and later for Robert

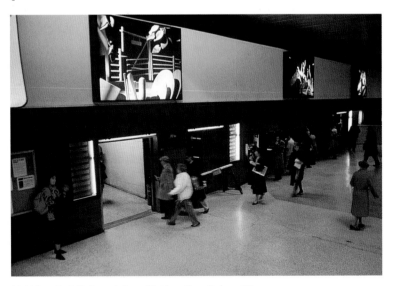

Light-box installation at Penn Station, New York, 1988.

Venturi, the preeminent postmodern theorist. Driving out West in 1984 to teach at Cal Arts, I was confronted with these traditions seen against the historical backdrop of the American landscape, the building of the railroads, the conquest of the continent and the near-destruction of the Native American way of life. The ten-year period from about 1870 to 1880 was mythologized through dime-store novels and eventually film. I was fascinated most by how this one moment became so important both to national identity and to the evolution of film as a popular medium. Film was created in constant dialogue with its audience and was the result of psycho-social needs, desires, prejudices and fears. The creation of the narrative structure in film, and particularly in the Western, was really a creation of its public rather than some ivory-tower author. In a parallel fashion, with the failure of Modernism, Postmodernism promised once again to examine and reflect the needs of its audience. All these ideas played into my Western images.

SJ: *The Western definitely was formative in terms of structuring an American mythology. Were there specific films that you thought were important, both to the formation of that mythology and to the work you were doing at the time?*
JC: I looked at all of the popular westerns, from Clint Eastwood films to *Shane, High Noon, Red River* and others by Howard Hawks and John Ford. I based some of the structures in my photos on the buildings in Western towns in studio back lots.

SJ: *Images like* Chuckwagon with Yucca *and* Kitchen Window with Corral *suggest a version of American history caught midway between myth and reality.*
JC: I was captivated by the myth, and I wanted to reveal something imaginary that reflected the psychic needs of America. In reality, the sheer scale of the landscape is unlike anywhere else. The two photos you mentioned were done at the end of the Western series, when I was starting to mix elements of the domestic still-life with the mythical West.

SJ: *Did your decision to create large-format images stem from wanting to suggest the feeling of those wide, open spaces?*

JC: Actually, I started making the big images—50 by 60 inches—for the commercial-style light-boxes. More recently, the large color prints are made in an attempt to create the illusion of large interior spaces that invite the viewer in. My photographs just gradually grew from 24 by 30 inches on up.

SJ: *You mentioned the idea of creating an illusionistic space in your images, which for me raises the issue of tableau photography. I'm guessing that you feel some affinity with artists like William Christenberry, Laurie Simmons, David Levinthal, Gregory Crewdson, Cindy Sherman and others who construct sets and scenes specifically for the purpose of photographing them.*

JC: I consider myself part of the generation of artists that emerged in the late 1970s and early '80s, including Cindy Sherman, Laurie Simmons, Richard Prince, Sherrie Levine and others. For better or worse, what differentiates my work has been a more plastic synthesis of architecture, design, photography and film.

SJ: *Have critics paid an undue amount of attention to the stylistics of your work rather than its political or social content? In general, what have you thought of the critical response to your work?*

JC: I don't necessarily expect viewers to read the work as I do. I don't feel misunderstood or misrepresented in any large sense. There was one scathing review in the *Los Angeles Times* of a show I did in San Diego. It really touched a nerve. Ironically, I was kind of thrilled. The writer thought my work was "inhuman" and without feeling. She described the effect my work can have, but she had an extremely negative reaction.

When I did the light-box installation at the Staten Island Ferry Terminal, Hal Foster wrote an article about it for *Art in America*. He discussed Freud's notion of the uncanny, and introduced me to the writings of Gilles Deleuze through a brilliant essay on the simulacra, which at that time had not yet been published in English.

SJ: *You've managed to synthesize diverse philosophical, art historical and personal influences into your art. Do you feel your work has developed organically?*

JC: As a student, I had to adapt to three radically different environments. In Minnesota, as an undergraduate, I had very little connection to the possibility of becoming an artist. Intellectually, however, it was very stimulating, thanks largely to the impact of one of my teachers, the artist and sculptor Siah Armajani. When I moved to New York to attend a graduate program at the Whitney, the art world suddenly was made accessible and down to earth. I was exposed to a more Marxist orientation and to the Frankfurt School. In California, where I went to Cal Arts to be John Baldessari's teaching assistant, there was a sense of humor, a more playful attitude, and an even more demystified tie to the marketplace. The openness was a bit disarming. I discovered idealism in Minnesota, political engagement at the Whitney, and freedom in California.

SJ: *Freedom, or its lack, has been a recurring theme in your work, particularly with the prison images made during the last few years. Architecture as an emblem of social structure and control always has been one of your primary concerns, and the prison is the ultimate authoritarian structure created by our culture. The prison images seem to signify the apex of your thematic concerns thus far. How did these images originate?*

JC: I was working on a set of pictures that dealt with the relationship between architecture and the development of different cultural institutions in Europe during the Enlightenment. As architecture, prisons are relatively camouflaged, hidden from the public, the same way that prisoners themselves are kept out of sight. I decided to study and depict the social history of prisons through their architecture, and I researched the development of different types from the eighteenth century to the present. I discovered about nine basic prison types. In the United States, the two main models are the radial prison—for example, the Eastern Pennsylvania State Penitentiary in Philadelphia—and the Auburn/Sing Sing plan. The radial plan is based on isolation and solitary confinement. Prisoners eat alone and

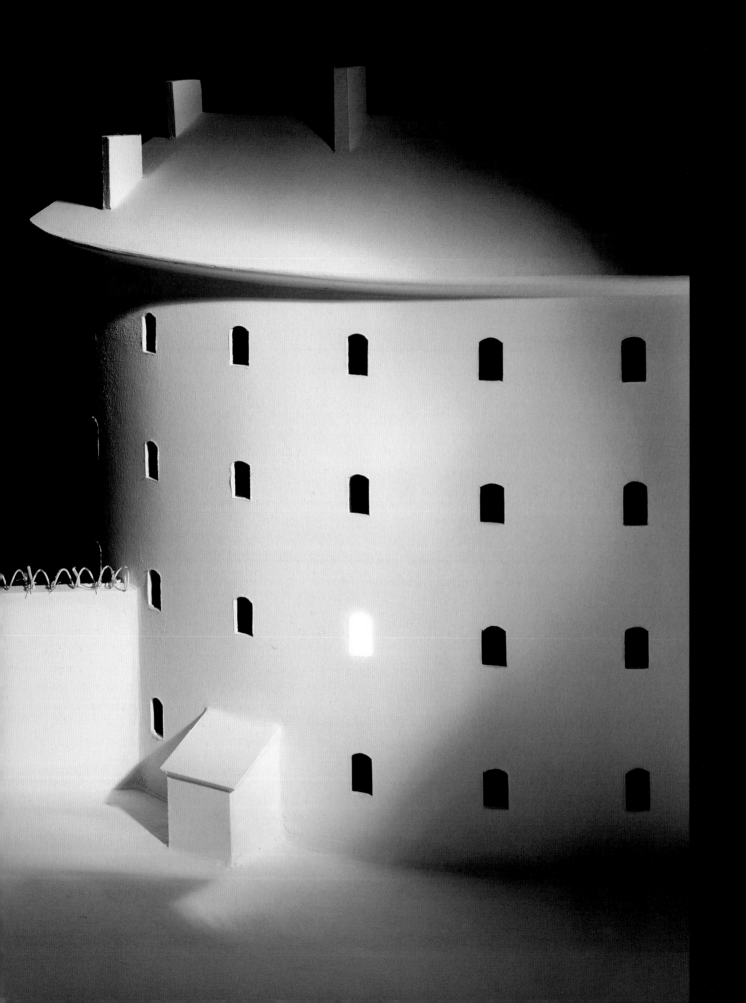

have private exercise rooms. They are supposed to commune only with God. Taking punishment out of the public arena was a Quaker reform. Confinement was connected to the idea of redemption, but a lot of prisoners in places like Philadelphia—who were Italian Catholics, coming from crowded tenements and large, extended families—didn't have that kind of religious background, so for them the idea of isolation was extremely disorienting. In contrast, the Auburn plan was based on the idea of social interaction, so prisoners would work, eat and exercise together.

The prison images also present a distillation of what I have been trying to do all along. My intention with this series was in part to critique the notion of the artist as an isolated individual, separated from society. I've always been somewhat ambivalent about this, because I value the idea of individual research and diligence. The jail-cell images are a critique of my artistic process but they also celebrate the idea of solitude.

SJ: *Have you come to any conclusions about secluding yourself as an artist, spending time alone creating these images, and adhering to or challenging the myth of the artist as existing outside mainstream culture?*

JC: I'm not sure what my conclusions would be. I look at making art as a process of social dialogue. Now I'm trying to reduce the images to their bare essentials. The interior rooms are not only a reflection of my studio but also a reflection of the mechanisms of photography. The cell is a little box, like the camera, and the window is an aperture that lets in light. The room is a camera obscura.

SJ: *I see a similar corollary between the camera and the panopticon, the model by which all areas of the prison can be seen from one vantage point. Just as the guard scans the prison from his viewpoint in the panopticon, the photographer has been thought of as capable of observing reality through the all-seeing camera lens. There's more skepticism of this notion during the past two decades, yet a certain blind belief in the photographic and the visual persists, as if to see all—through the camera lens or from the prison panopticon—is to know all.*

JC: I see what you're saying. I'm skeptical about the visual. Falsehood was a given when I started this work. Every so often a new truth is concocted to serve new political needs. The novels by Latin American magic realists showed how history is rewritten by each successive military dictatorship. I look at photography the same way: as a fiction, as representative of a particular point of view. Today, we too readily accept what we read or see on the news as true. Seventy or eighty years ago, people were not as likely to take information for granted. A city like New York had a hundred different newspapers, each with a different viewpoint, and you could choose the one you liked or read conflicting views and debate their merits. There is not so much debate today. I try to address the limits of subjectivity—how it's constructed and how we are locked into our own narrow vision.

SJ: *How do we get out?*
JC: I don't know that I can answer that. Right now, I'm tempted to reshoot the same jail cell for the rest of my life.

SJ: *In order to continually rewrite the same fiction, or to arrive at some ultimate truth?*
JC: There's no ultimate truth I'm trying to get at.

SJ: *Your impulse to continually rework the same jail cell reminds me of something you mentioned in conversation with Gregory Crewdson in 1993 about the cultural legacy of Minimalism, and about its ideological function to suppress emotion and pleasure. Your desire to strip away all but the essentials in your photographs adheres to Minimalist stylistics, yet you're able to use the look of Minimalism to usurp what is considered the movement's anti-emotional content. I think your images can be very emotional.*
JC: The prison images address the idea of denial and the absence of pleasure as it is related to my own ethnic heritage. The Protestant ethic, which values labor over pleasure, is something I felt very ambivalent about early on, and I fought with it. I've brought the issue to the foreground in my work by exaggerating the labor-intensive act of building the models.

PLATE 60
Panopticon #3, 1993.

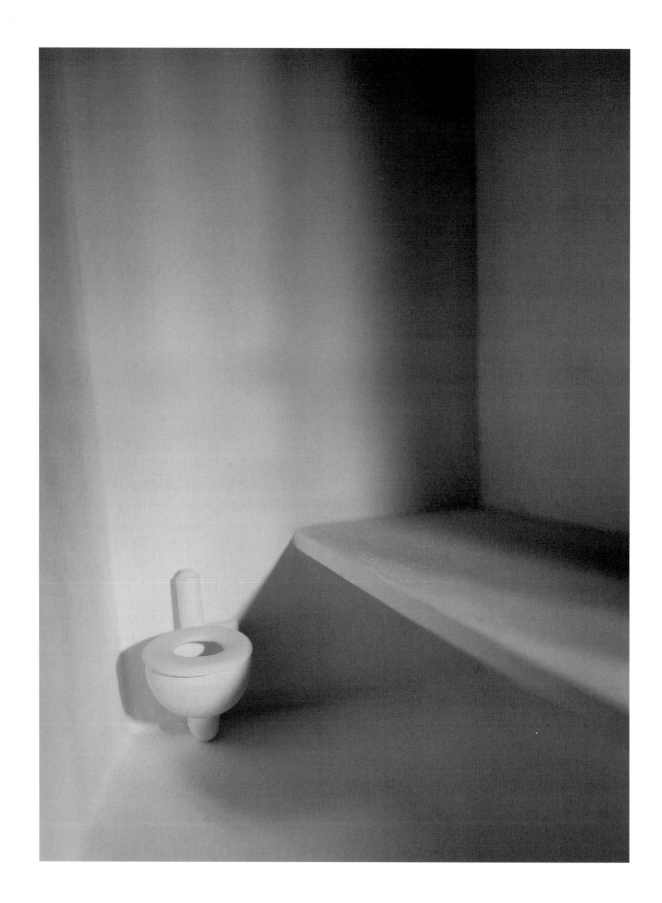

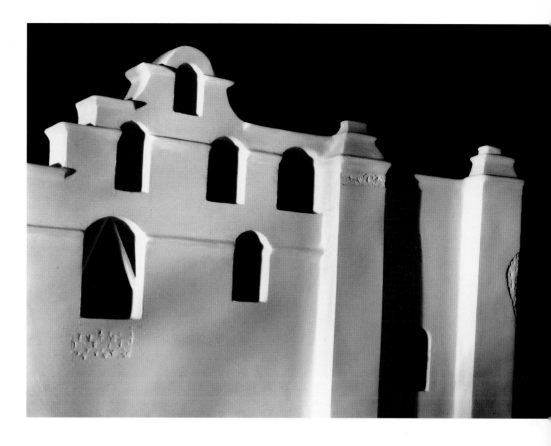

Facing page:
PLATE 61
Prison Cell with Toilet, 1993.

PLATE 62
Mission Façade, 1988.

SJ: *Throughout your career you've merged sculpture, photography and installation art in ways that reflect not only Modernism's emphasis on formal accomplishment but also the Postmodern practice of deconstruction. Do you align yourself with any particular art-historical tradition?*

JC: As early as 1976 I identified with the idea of the Postmodern as formulated by Robert Venturi, before the term entered the discussion of other visual arts via Craig Owens. Venturi was influenced by Pop Art, and he approached architecture as a sign system rather than looking at it as what he called "Space as God." I also was impressed at the time with the work of Dan Graham. Here was someone dealing with Venturi's ideas about architecture within the framework of conceptual art and sculpture.

That said, I'm not tied to any tradition, and I never thought of my work as fitting into the world of fine-art photography. I was more interested in how images were used in advertising and the mass media. I saw my light-boxes as cuts or interventions in the urban context of advertising in a way that's related to Gordon Matta-Clark's

more literal cuts in the walls of the East River piers.

As a student, looking at the history of Modernism, I was inspired by the Constructivist call to move art into life. Recently, as I've been working on lithographs, I've been thinking more about the photomontage of the Surrealists or Berlin Dada of the 1920s and '30s. This socially engaged approach lost its momentum after World War II, particularly in this country. There was an unhealthy, conservative regrouping in the separation of media: the idea of painting about painting, or photography about photography. The arts became depoliticized and separated from larger issues in society. Pop Art readdressed those issues in the 1950s and '60s, and conceptual art did too. By the 1980s a lot of artists tried to reach beyond the shrinking audience for conceptual art. Desire operated less and less in the realm of art during the 1970s. It took the reemergence of visual arts and photography in the '80s to address a larger audience and—to various and often conflicting ends—bring pleasure back into the equation. I came out of that moment.

VITA

1953 Born in Lansing, Michigan
 Lives in New York

EDUCATION
1979 California Institute of Arts, M.F.A.
1977 Whitney Independent Study Program
1976 Minneapolis College of Art and Design, B.F.A.
1971-73 Michigan State University

AWARDS
1995 John Simon Guggenheim Memorial Foundation
1994 New York Foundation for the Arts Fellowship
1990 N.E.A., Visual Arts Fellowship
1989 New York Foundation for the Arts Fellowship
1986 N.E.A., Visual Arts Fellowship
1985 New York Foundation for the Arts Fellowship
1982 New York State Council on the Arts: Visual Artists
 Sponsored Project Grant

SELECTED SOLO EXHIBITIONS
1996–97 The Ansel Adams Center for Photography, San Francisco
 Williams College Museum of Art, Williamstown

1996 Galleria Galliani, Genoa, Italy
 S.L. Simpson Gallery, Toronto

1995 Michael Klein Gallery, New York

1994 Galleria Galliani, Genoa, Italy
 Richard Levy Gallery, Albuquerque

1993 Michael Klein, Inc., New York

1991 Birmingham Museum of Art, Birmingham
 Gallerij Bruges La Morge, Bruges, Belgium
 James Hockey Gallery, WSCAD, Farnham, England
 Michael Klein, Inc., New York
 Kunststichting Kanaal, Kortrijk, Belgium, in collaboration
 with Tony Oursler
 Photographic Resource Center, Boston University, Boston
 The University of Iowa Museum of Art, Iowa City

1990 Galleria Facsimilie, Milan
 Museum of Photographic Arts, San Diego
 Urbi Et Orbi, Paris
 Vrej Baghoomian Gallery, New York

1989 Galerie De Lege Ruimte, Bruges, Belgium
 Neuberger Museum, SUNY Purchase
 The University of South Florida Art Museum, Tampa

1988 Kuhlenschmidt/Simon Gallery, Los Angeles
 Pennsylvania Station, New York

1987 303 Gallery, New York
 Michael Klein, Inc., New York

1985 Kuhlenschmidt/Simon Gallery, Los Angeles
 Minneapolis College of Art and Design, Minneapolis

1984 Diane Brown Gallery, New York
 Sonnabend Gallery, New York

1983 St. George Ferry Terminal, Staten Island

1982 CEPA Gallery, Buffalo
 Sonnabend Gallery, New York

1981 Franklin Furnace, New York

1979 Artists Space, New York

SELECTED GROUP EXHIBITIONS
1996 "After Dark: Nocturnal Images," Barbara Mathes Gallery
 "The House Transformed," Barbara Mathes Gallery
 "McDowell Exhibition," Hood Museum of Art, Dartmouth
 College, Hanover, and the Art Gallery at the
 University of New Hampshire

1995 "4 Photographers," Rena Bransten Gallery, San Francisco
 "Campo," Venice Biennale. Traveled to Torino, Italy,
 and Konstmuseum, Malmo, Norway.
 "Prison Sentences: The Prison as Site/The Prison as Subject,"
 Eastern Pennsylvania State Penitentiary, Philadephia

1994 "Building Dwelling Thinking: A Group Exhibition," Lowinsky
 Gallery, New York
 "Forecast: Shifts in Direction," Museum of New Mexico, Santa Fe
 "House Rules," Wexner Center for the Visual Arts, Columbus
 "Imagini d'Affezione," Castello Monumentali di Lerici, Italy.
 "Stilled Pictures—Still Life," Fine Arts Center Galleries,
 University of Rhode Island, Kingston
 "The Subject is Architecture," University of New Mexico Art
 Museum, Albuquerque

1993 "American Made: The New Still-Life," Isetan Museum of Art,
 Hokkaido, and Obihito Museum of Art, Japan. Traveled to
 the Royal College of Art, London.
 "Collecting for the 21st Century: Recent Acquisitions and
 Promised Gifts," The Jewish Museum, New York
 "Fabricated Realities," Museum of Fine Arts, Houston
 "From New York: Recent Thinking in Contemporary Photography,"
 Donna Beam Fine Art Gallery, University of Nevada
 at Las Vegas
 "Kurswechsel," Michael Klein Inc., at Transart Exhibitions, Cologne
 "Sampling the Permanent Collection," Museum of Fine Arts, Boston

1992 "Interpreting the American Dream," Galerie Eugen Lendl, Graz, Austria. Traveled to Galerij James va Damme, Antwerp.
"More Than One Photography," Museum of Modern Art, New York
"Une seconde pensee du paysage," Domaine de Kerguehennec, Centre d'Art Contemporaine, Locmine, France

1991 "1986-1991: 5 Jaar De lege Ruimte," Galerie de Lege Ruimte, Bruges, Belgium
"Constructing Images: Synapse Between Photography and Sculpture," Lieberman & Saul, New York. Traveled to Tampa Museum of Art, Center for Creative Photography, Tucson, and San Jose Museum of Art, California.
"Pleasures and Terrors of Domestic Comfort," Museum of Modern Art, New York

1990 "Abstraction in Contemporary Photography," Emerson Gallery, Hamilton College and the Anderson Gallery, Virginia Commonwealth University, Richmond
"Anninovanta," Galleria Comunale d'Arte Moderna, Bologna, Italy
"Das Konstruierte Bild. Arrangiert und Inszeniert," Badische Kunstverein Karlsruhe, Germany
"The Liberated Image: Fabricated Photography Since 1970," Tampa Museum of Art

1989 "Altered States," The Harcus Gallery, Boston
"Beyond Photography," Krygier Landau Contemporary Art, Santa Monica
"Das Konstruierte Bild. Fotografie—Arrangiert und Inzeniert," Kunstverein Munchen, Germany. Traveled to Kunsthalle Nurnberg, Forum Bottcherstrasse, Bremen, and Badischer Kunstverein Karlsruhe.
"Decisive Monuments," Ehlers Caudill Gallery, Chicago
"Encore II: Celebrating Fifty Years," The Contemporary Arts Center, Cincinnati
"Fauxtography," Art Center College of Art and Design, Pasadena
"The Mediated Imagination," Visual Arts Gallery, SUNY Purchase
"New York Artists," Linda Farris Gallery, Seattle
"Parallel Views," ARTI, Amsterdam
"The Photography of Invention—American Pictures of the 1980s," National Museum of American Art, Washington, DC. Traveled to the Walker Art Center, Minneapolis.
"Suburban Home Life: Plotting the American Dream," Whitney Museum of American Art, New York. Traveled to Whitney Museum of American Art, Stamford, Connecticut.

1988 "Complexity and Contradiction," Scott Hanson Gallery, New York
"Fabrication—Staged, Altered and Appropriated Photographs," Sert Gallery, Carpenter Center for the Visual Arts, Harvard University, Boston.
"James Casebere, Stephen Prina, Christopher Wool," Robin Lockett Gallery, Chicago
"Made In Camera," VAVD Editions, Stockholm
"Plane Space: Sculptural Form and Photographic Dimensions," The Photographers' Gallery, London

"Playing For Real, Toys and Talismans," Southampton City Art Gallery, England. Traveled to Ikon Gallery, Birmingham and Chapter Arts, Cardiff.

1987 "3 Americans, 3 Austrians," Fotogalerie Wien, Vienna
"Arrangements for the Camera: A View of Contemporary Photography," The Baltimore Museum of Art
"Bilder 30," Fotogalerie Wien, Vienna
"CalArts: Skeptical Belief(s)," The Renaissance Society, University of Chicago. Traveled to Newport Harbor Museum, Newport Beach, California.
"Cross-References: Sculpture into Photography," Walker Art Center, Minneapolis
"Kunst Mit Photographie," Galerie Ralph Wernicke, Stuttgart
"Photography and Art: Interactions Since 1946," Los Angeles County Museum of Art and The Fort Lauderdale Museum of Art. Traveled to The Queens Museum.
"The Pride of Symmetry," Galerie Ralph Wernicke, Stuttgart
"Small Wonders," Barry Whistler Gallery, Dallas
"This is Not a Photograph: Twenty Years of Large-Scale Photography, 1966-1986," The John and Mable Ringling Museum of Art, Sarasota. Traveled to Akron Art Museum and The Chrysler Museum, Norfolk.

1986 "The Fairy Tale: Politics, Desire, and Everyday Life," Artists Space, New York
"Foto Cliche," Victoria Miro Gallery, London; Orchard Gallery, Derry
"James Casebere, Clegg & Guttman, Ken Lum," Galerie Bismarckstrasse, Cologne
"Milano Triennale," Milan
"Photographic Fictions," The Whitney Museum of American Art, Stamford, Connecticut.
"Photographs," 303 Gallery, New York
"Picture Perfect," Kuhlenschmidt/Simon Gallery, Los Angeles
"The Real Big Picture," The Queens Museum
"Signs of the Real," White Columns, New York
"Sonsbeek 86: International Sculpture Exhibition," Holland
"TV Generation," L.A.C.E., Los Angeles

1985 "Biennial Exhibition," Whitney Museum of American Art, New York
"James Casebere, Jeff Koons, Larry Johnson," 303 Gallery, New York
"Rounding Up the Usual Suspects," Fay Gold Gallery, Atlanta

1984 "A Decade of New Art," Artists Space, New York
"The Success of Failure," Diane Brown Gallery, New York

1983 "Art Park," Lewiston, New York
"Artists Use Photography," American Graffiti Gallery, Amsterdam. Traveled to Marianne Deson Gallery, Chicago.
"Images Fabriquées," Centre Georges Pompidou, Paris. Traveled to Museum voor Aktuel Kunst, Hasselt, Belgium.
"In Plato's Cave," Marlborough Gallery, New York

1982 "The Fabricated Image," Delahanty Gallery, Dallas
"Tableaux: Nine Contemporary Sculptures," The Contemporary
Art Center, Cincinnati

1981 "Eight Contemporary Photographers," University of South
Florida Art Museum, Tampa
"Erweiterete Fotografie," Wiener International Biennale, Vienna
"The Exhibition," California Institute of the Arts, Valencia
"Photo," Metro Pictures, New York

1980 "Group Show," Annina Nosei Gallery, New York
"The Real Estate Show," Co-Lab, New York
"The Staged Shot," Delahanty Gallery, Dallas

1979 "Fabricated to be Photographed," San Francisco Museum of
Modern Art. Traveled to The University of New Mexico,
Albuquerque, Albright-Knox Art Gallery, Buffalo, and
Newport Harbor Art Museum, Newport Beach, California.
"Southern California Invitational/Photo," University of Southern
California, Los Angeles

Selected Bibliography

1996 Batchen, Geoffrey. "James Casebere's Prison Series,"
Creative Camera.

1995 Aletti, Vince. "Voice Choices," *Village Voice,* March 28, p. 9.
Hagen, Charles. "James Casebere," *New York Times,* April 14,
p. C14.
Ziolkowski, Thad. "James Casebere, Michael Klein Gallery,"
Artforum, September.

1994 Anon. "James Casebere: Cafeteria and Cell with Toilet," *Print
Collector's Newsletter,* May–June, p. 66.
_____"James Casebere Silverprints," *Paris Review,* No. 130,
Spring, pp. 229-235.
_____"Wexner Center Presents Social Constructions and
Electronic Games by Artists," *Flash Art,* Summer, p. 35.
Casebere, James. "Cafeteria and Cell with Toilet," *Print Collector's
Newsletter,* Volume 25, Number 2, May–June, p. 66.
Conti, Viana. "James Casebere," *Flash Art,* March, p. 45.
Davis, Keith. *An American Century of Photography, From Dry-Plate
to Digital, The Hallmark Photographic Collection,* Abrams,
pp.306,361.
Hall, Jacqueline. "New Angles on 'Home': '90s Domestic Spaces
Analyzed, Challenged by Varied Ideologies," *Columbus
Dispatch,* September 18.
"House Rules," special issue of *Assemblage,* MIT Press Journal.
Luca, Elisabetta. "James Casebere," *Juliet Art Magazine,* Trieste,
Italy, June, p. 45.
Rubenstein, Raphael. "The Art of Imprisonment," *Metropolis,*
May, p. 48.
Ryan, Jeffry. "Twenty One Steps: A New Printmaking Aesthetic,"
Hot Off The Press, University of New Mexico Press, Tamarino
Institute, pp. 110-111.
Seiko, Uyeda. "Quest for Lost Image," *Seven Seas,* Japan, October,
pp. 171-175.

1993 Aletti, Vince. "Voice Choices," *Village Voice,* May 25, p. C26.
Carroll, Patty. *American Made: The New Still Life* (exhibition
catalog), Japan Art and Culture Association, Tokyo.
Casebere, James; Crewdson, Gregory. "The Jim and Greg Show,"
Blind Spot, Issue 2.
Kalina, Richard. "James Casebere at Michael Klein," *Art in
America,* October, pp. 127-129.
Lifson, Ben. "A Model Prisoner: James Casebere," *Artforum,*
May, pp. 87-89.
McQuaid, Kate. "Asking Why: The MFA's 'Building A Collection'
is art that raises questions," *Boston Phoenix,* March 19, p. 21.
_____"Mod Squad," *Boston Phoenix,* February 5.
Pinchbeck, Daniel. "Openings," *Art & Antiques,* April, p. 22.
Saltzstein, Katherine. "Breaking out of the Mold," *Albuquerque
Journal,* July 25, p. F2.
Shefcik, Jerry. *From New York: Recent Thinking In Contemporary
Photography* (exhibition catalog), Donna Beam Fine Art
Gallery, University of Nevada, Las Vegas.
Sherman, Mary. "'Building A Collection' at the Museum of Fine
Arts," *Boston Herald,* January 29, p. S4.

1992 Batchen, Geoffrey. "On Post-Photography, Constructing Images:
Synapse Between Photography and Sculpture," *Afterimage,*
Vol. 20, No. 3, October, p.17.
Bonetti, David. "Art," *San Francisco Examiner,* August 28, p. C-2.
Casebere, James. "Venice Ghetto," *Villa Val Lemme,* Capriata
d'Orba, Italy.
Loke, Margaret. "Constructing Images: Synapse Between
Photography and Sculpture at Lieberman & Saul," *Artnews,*
Vol. 91, No. 2, February, p. 128.
Mclay, Catherine. "Twice Captured Images: By Lens and Then By
Hand," *San Jose Mercury News,* July 10, p. 45.
Robson, Julien. *Interpreting The American Dream* (exhibition
catalog), Galerie Eugen Lendl, Graz.

1991 Anon. "James Casebere," *Juliet Art Magazine,* Trieste, Italy,
December, p. 33.
_____"James Casebere: archivaris van Amerikaans industrieel
erfgoed," *WB,* May 16, p. 14.
_____"Photography," *The New Yorker,* June 10, p. 18.
Coleman, A.D. "When Photos and Sculptures Get Married,"
New York Observer, November 11.
Conklin, Jo-Ann. *James Casebere* (exhibition brochure),
University of Iowa Museum of Art, Iowa City.
Cross, Andrew; Morgan, Stuart. *James Casebere* (exhibition
catalog), James Hockey Gallery, West Surrey College of Art
and Design.
Friedman, Ann. "Photographs Mix Ordinary, Eerie," *Birmingham
News,* October 27, pp. 1F, 6F.
Garlake, Margaret. "James Casebere," *Art Monthly,* December,
pp. 15-16.
Goldwater, Marge. *James Casebere* (exhibition brochure), Michael
Klein, Inc., New York.
Higuchi, Shoichiro. "James Casebere's Collection of the Memory,"
Idea, Tokyo, No. 226, pp. 126-129.
Lambrecht, Luk. "Kunst," *Kaack Weekend,* May 22, p. 18.

Marger, Mary Ann. "Latest In Smart Art," *St. Petersburg Times,* December 31.

Milanti, Joanne. "Photographers Shoot for Depth," *Tampa Tribune,* December 6.

Nelson, James R. "Casebere Creates Worlds of Emptiness and Artifice," *Birmingham News,* November 19, p. 4F.

Rian, Jeff. "James Casebere," *Arts Magazine,* October, p. 79.

Romano, Gianni. "James Casebere," *Flash Art,* Edizione Italiana, No. 160, February-March, pp. 86-87.

Schaffner, Ingrid. *Constructing Images* (exhibition catalog), Lieberman Saul Gallery, New York.

Silver, Joanne. "Architectural Photos Build on Viewer's Experience," *Boston Herald,* March 29, pp. 517-518.

Troncy, Eric. "James Casebere," *Metropolis,* No. 2, pp. 36-37.

Wilner-Stack, Trudy. *Model Fictions. The Photographs of James Casebere* (exhibition brochure), Birmingham Museum of Art.

Wise, Kelly. "The Juncture of the Real and the Imagined," *Boston Globe,* April 16.

1990 Anon. "Goings On About Town," *The New Yorker,* March 5.

Casebere, James. "Calendar by James Casebere," *Interview,* July, p. 126.

Christensen, Judith. "Waiting for Life to Happen," *Artweek,* November 29, pp. 13–14.

Daxland, John. "Sculptures That Force You To Look," *Daily News,* February 17.

Freudenheim, Susan. "Photographs by Casebere Display Lack of Feeling," *Los Angeles Times,* October 27, pp. F1–F10.

Jarmusch, Ann. "Casebere Show Lights Up Recesses of Mind," *San Diego Tribune,* October 26, pp. C1, C6.

Levin, Kim. "Bad Timing," *Village Voice,* March 6, p. 102.

_____ "Voice Choices," *Village Voice,* March 6, p. 109.

Lewis, James. "James Casebere," *Artforum,* May, p. 186.

Muschamp, Herbert. *Nightlights* (exhibition catalog), APAC Centre d'Art Contemporain, Nevers, France.

Princenthal, Nancy. "James Casebere at Vrej Baghoomian," *Art in America,* June, p. 170.

1989 Anon. *Encore—Celebrating Fifty Years* (exhibition catalog), Contemporary Arts Center, Cincinnati.

Althorpe-Guyton, Marjorie. "Plane Space..., The Photographers Galler," *Flash Art,* January–February, p. 130.

Bayliss, Sarah; Hoover, Christopher Robert; Kwon, Miwon. *Suburban Home Life: Tracking the American Dream (*exhibition catalog), Whitney Museum of American Art, New York.

Grundberg, Andy; et. al. *Abstraction in Contemporary Photography* (exhibition catalog), Emerson Gallery.

Hackett, Regina. "Poker-faced NY pop artists exhibit some staying power," *Seattle Post-Intelligencer,* February 21, pp. C1, C3.

Hammond, Pamela. "Sculpture," *Artnews,* p. 178.

Kohler, Michael, ed. *Das Konstruierte Bild* (exhibition catalog), Kunstverein Munchen, Germany.

Marger, Mary Ann. "University Opens its Doors to the World of Art," *St. Petersburg Times,* January 21, p. 1D.

Milanti, Joanne. "Avant-Garde Art Finds a Home," *Tampa Tribune,* January 20, pp. F1-2.

Roskam, Mathilde. *Parallel Views* (exhibition catalog), Arti et Amicitiae, Amsterdam.

Smith, Roberta. "Charting Traditions of Nontraditional Photography," *New York Times.*

_____*Playing Havoc: Notes on James Casebere's 'Tree Trunk with Broken Bungalow and Shotgun Houses'* (exhibition catalog), USF Art Museum, Tampa, and Neuberger Museum of Art, SUNY Purchase.

Steenhuis, Paul. "Droom Spoor," *Brij Nederland,* May.

Steinberg, Janet. "Just Say Faux," *Seattle Weekly,* February 8.

Welles, Elenore. "Beyond Photography," *Artscene,* April, p. 26.

Westerbeck, Colin. *Decisive Monuments* (exhibition brochure), Ehlers Caudill Gallery Ltd., Chicago.

Zimmer, William. "Five Photographic Portfolios," *New York Times,* July 16.

1988 Block, Valerie. "From One Surreal Landscape to Another," *New York Observer,* July 4-11, p. 10.

Cross, Andrew; McNeil, Helen. *Playing for Real: Toys and Talismans* (exhibition catalog), Southampton City Art Gallery.

Donahue, Marlena. "Reviews; James Casebere," *Los Angeles Times,* March 11.

Gardner, Colin. "CalArts; Skeptical Belief(s)," *Artforum,* April, p. 154.

Gerster, Amy. "Reviews; James Casebere, Kulenschmidt/Simon," *Artforum,* September, p. 151.

Jones, Amelia. "Connections to the Real," *Artweek,* March 26, p. 4.

Keonig, Peter. "Exhibition Explores Art of Directorial Photography," *The Enterprise,* April 1, p. 5a.

Leigh, Christian. *Complexity and Contradiction* (exhibition catalog), Scott Hanson Gallery, New York.

Mahoney, Robert. "Trains of Thought," *New York Press,* August 26, p. 10.

Rubin, Birgitta. "Med Kameran i Fokus," *DN Pa Stan,* October–November.

Wise, Kelly. "'Fabrications': A Probing, Instructive Exhibit," *Boston Globe,* April 5, p. 66.

1987 Aletti, Vince. "Photo," *Village Voice,* June 3.

Bromberg, Craig. "Teaching Tomorrow's Avant Garde," *Artnews,* September, pp. 100-103.

Currah, Mark. "Reviews-Interim Art; Barbara Ess, James Casebere," *City Limits,* August.

Goldwater, Marge. *Cross References: Sculpture into Photography* (exhibition catalog), Walker Art Center, Minneapolis, and The Museum of Contemporary Art, Chicago.

Grundberg, Andy. "Critics Choices: Photography," *New York Times,* June 14.

Hart, Claudia. "James Casebere: 303 Gallery, Michael Klein Gallery," *Artscribe International,* September/October, pp. 80-81.

Jurgenssen, Birgit. *New York—Wein* (exhibition catalog), Fotogalerie Wien, Vienna.

Kent, Sarah. "New Reviews; Barbara Ess and James Casebere," *Time Out,* July 29-August 5.

Kunst Mit Photographie (exhibition catalog), Galerie Ralph Wernicke, Stuttgart.

Nightfire (exhibition catalog), De Appel, Amsterdam.

Rubey, Dan. "James Casebere," *Artnews*, November, p. 205.
Saltz, Jerry. "Beyond Boundaries; New York's New Art,"
　　Van Der Marck Press.
Smith, Roberta. "James Casebere," *New York Times*, June 5, p. C32.
Wallis, Brian, ed. *Blasted Allegories* ("Three Stories" by James
　　Casebere), The New Museum Press, New York.

1986　Anon. *Photographic Fictions* (exhibition catalog), Whitney Museum
　　of American Art, Stamford, Connecticut.
　　Bos, Saskia. *Sonsbeek 86: International Sculpture Exhibition*,
　　(exhibition catalog), Arnham, Holland.
　　Hoy, Ann. *Fabricated Photographs*, Abbeville Press.
　　Indiana, Gary. "The Death of Photography," *Village Voice*,
　　September 30.
　　Langsfield, Wolfgang. "Moderne Kunst im Park," *Siddeutsche*,
　　Donnerstag, August 28.
　　Verzotti, Giorgio. "Arte Santa," *Domus*, September.
　　Wallis, Brian, ed. *Rethinking Representation: Art After Modernism*,
　　The New Museum Press, New York.

1985　Brooks, Rosetta. "From the Night of Consumerism to the Dawn
　　of Simulation," *Artforum*, February, pp. 76–81.
　　Dank, Ralf. "Sonsbeek 86," *Kunstforum*, September–October, p. 254.
　　Foster, Hal. "The Expressive Fallacy," *Recordings: Art, Spectacle,*
　　Cultural Politics, Bay Press, Port Townsend, Washington,
　　pp. 59–77.
　　Gardner, Colin. "Art: Abstract Western Scenes," *Los Angeles Reader*,
　　July 5, p. 6.
　　Muchnic, Suzanne. "The Art Galleries," *Los Angeles Times*, June 28,
　　pp. 12–13.
　　Raynor, Vivien. "Fiction: Diane Brown Gallery," *New York Times*,
　　April 23.
　　Russell, John. "Art: Whitney Presents Its Biennal Exhibition,"
　　New York Times, March 22, p. C23.

1984　Hagen, Charles. "Reviews," *Artforum*, Summer, pp. 90–91.
　　Levin, Kim. "Immaculate Conceptualist," *Village Voice*, July 3, p. 91.
　　Naef, Weston. *New Trends*, Nippon Press.
　　Sayag, Alan. *Images Fabriquées* (exhibition catalog), Centre Georges
　　Pompidou, Paris.
　　Zelevansky, Lynn. "James Casebere," *Artnews*, Summer,
　　pp. 192–193.

1983　Armstrong, Tom. "Independent Study Program, Fifteenth
　　Anniversary," Whitney Museum of American Art, New York.
　　Foster, Hal. "Uncanny Images," *Art In America*, November,
　　pp. 202–204.
　　Godeau, Abigail Solomon. *In Plato's Cave* (exhibition catalog),
　　Marlborough Gallery, New York.
　　Grundberg, Andy. "Post-Modernists in the Mainstream,"
　　New York Times, November 20, pp. H27, 43.
　　Olander, William. "Missing Persons," *Artnews*, February,
　　pp. 112-115.

1982　Foster, Hal. "Mel Bochner and James Casebere at Sonnabend,"
　　Art in America, October, p. 132.

Kamholtz, Johnathan Z. "Assembling Tableaux," *Dialogue Quarterly*,
　　November–December, pp. 7–8.
Klein, Michael. *Tableaux: Nine Contemporary Sculptures* (exhibition
　　catalog), The Contemporary Arts Center, Cincinnati.
Miller, John. *Cave Canem: Stories and Pictures by Artists*, Cave
　　Canem Books, New York.
Owens, Craig. "Back to the Studio," *Art in America*, January,
　　pp. 99-107.
Raynor, Vivien. "Mel Bochner and James Casebere at Sonnabend,"
　　New York Times, April 16, p. C22.
Smith, Roberta. "Some Things Old, Some Things New," *Village
　　Voice*, April 27, p. 98.

1981　Glueck, Grace. "The Scene from Soho to Tribeca," *New York
　　Times*, January 30, p. C19.

1980　Armstrong, Richard. "Review," *Artforum*, p. 107.
　　Fischer, Hal. "Curatorial Constructions," *After Image*, March,
　　pp. 7–9.

1979　Coke, Van Deren. *Fabricated to be Photographed* (exhibition
　　catalog), San Francisco Museum of Modern Art.
　　Muchnic, Suzannne. "Photography as Art and History,"
　　Los Angeles Times, March 11, p. 93.
　　Murray, Joan. "Fabricated for the Camera," *Artweek*, December 8,
　　pp. 1, 11.
　　Porter, Diana. "The Primacy of Idea," *Artweek*, March 10, p. 11.

PUBLIC COMMISSIONS

1993　University of Washington, Seattle. Six light-boxes installed
　　in bus shelters, commissioned by Washington State Arts
　　Commission.

1991　Minnesota History Center, St. Paul. Group of brass elements
　　installed in terrazzo floor of main hall, commissioned by
　　Minnesota Arts Board and Minnesota Historical Society.

1990　Kortrijk Station, Kortrijk, Belgium. Light-box installation in collabo-
　　ration with Tony Oursler, commissioned by Kunststichting
　　Kanaal.

1988　Pennsylvania Station, New York. Series of 11 light-boxes installed
　　in station, commissioned by the Public Art Fund.
　　Piedmont Park, Atlanta. *Sherman's Bow Tie*, stucco sculpture,
　　commissioned by Atlanta Arts Festival.

1983　Art Park, Lewiston, New York. Light-box installation commissioned
　　by Art Park.
　　Staten Island Ferry Terminal, New York. Series of light-boxes
　　installed in the terminal, sponsored by New State Council
　　on the Arts, Artists' Sponsored Project Grant.

1980　New York, New York. Poster project in Lower Manhattan,
　　sponsored by Artists' Space.

CHECKLIST OF PLATES

1 *Tenement*, 1991. Gelatin silver print, 30 x 40 in. *

2 *Chuckwagon with Yucca*, 1988. Gelatin silver print, 30 x 40 in. *

3 *Shooting Gallery*, 1981. Gelatin silver print, 16 x 20 in. *

4 *Library I*, 1980. Gelatin silver print, 16 x 20 in. *

5 *Fan as Eudemonist: Relaxing after an Exhausting Day at the Beach*, 1975. Gelatin silver print, 10 x 8 in.

6 *Fork in the Refrigerator*, 1975. Gelatin silver print, 10 x 8 in.

7 *Bacillus Pestis*, 1976. Gelatin silver print, 10 x 8 in.

8 *Bed Upturning its Belly*, 1976. Gelatin silver print, 16 x 20 in.

9 *Life Story Number One, Part 1*, 1978. Gelatin silver print, 20 x 24 in.

10 *Life Story Number One, Part 2*, 1978. Gelatin silver print, 20 x 24 in.

11 *Life Story Number One, Part 3*, 1978. Gelatin silver print, 20 x 24 in.

12 *Life Story Number One, Part 4*, 1978. Gelatin silver print, 24 x 20 in.

13 *Life Story Number One, Part 5*, 1978. Gelatin silver print, 20 x 24 in.

14 *Life Story Number One, Part 6*, 1978. Gelatin silver print, 20 x 24 in.

15 *Life Story Number One, Part 7*, 1978. Gelatin silver print, 20 x 24 in.

16 *Life Story Number One, Part 8*, 1978. Gelatin silver print, 24 x 20 in.

17 *Life Story Number One, Part 9*, 1978. Gelatin silver print, 20 x 24 in.

18 *Life Story Number One, Part 10*, 1978. Gelatin silver print, 24 x 20 in.

19 Detail from *Storyboard*, 1979. Twenty dye destruction and gelatin silver prints and one text panel, each 5 x 7 in. on 11 x 14 in. paper.

20 Detail from *Storyboard*, 1979. Twenty dye destruction and gelatin silver prints and one text panel, each 5 x 7 in. on 11 x 14 in. paper.

21 *Courtroom*, 1979–80. Gelatin silver print, 16 x 20 in.

22 *Library II*, 1980. Gelatin silver print, 16 x 20 in.

23 *Desert House with Cactus*, 1980. Gelatin silver print, 16 x 20 in.

24 *Boats*, 1980. Gelatin silver print, 16 x 20 in.

25 *Driveway III*, 1981. Gelatin silver print, 16 x 20 in.

26 *Back Porch II*, 1982. Gelatin silver print, 20 x 16 in.

27 *Sutpen's Cave*, 1982. Gelatin silver print, 16 x 20 in.

28 *Subdivision with Spotlight*, 1982. Gelatin silver print, 16 x 20 in.

29 *Storefront*, 1982. Gelatin silver print, 16 x 20 in.

30 *Watertoys*, 1982. Gelatin silver print, 24 x 30 in.

31 *Waterfall*, 1983. Gelatin silver print, 30 x 24 in.

32 *Stonehouse*, 1983. Gelatin silver print, 30 x 24 in. *

33 *Cotton Mill*, 1983. Gelatin silver print, 30 x 24 in.

34 *Winterhouse*, 1984. Gelatin silver print, 40 x 30 in.

35 *Street with Pots*, 1983. Gelatin silver print, 30 x 24 in.

36 *Arches*, 1985. Gelatin silver print, 30 x 40 in.

37 *Pulpit*, 1985. Gelatin silver print, 40 x 30 in.

38 *Needles*, 1985. Gelatin silver print, 28 x 75 in.

39 *Covered Wagons*, 1985. Gelatin silver print, 40 x 30 in.

40 *Golden Apple*, 1986. Gelatin silver print, 30 x 40 in.

41 *Kitchen Window with Corral*, 1987. Gelatin silver print, 30 x 40 in.

42 *Industry*, 1990. Gelatin silver print, 30 x 40 in.

43 *Portuguese Beachfront*, 1990. Gelatin silver print, 30 x 40 in. *

44 *Venice Ghetto*, 1991. Gelatin silver print, 40 x 30 in.

45 *The Prison at Cherry Hill*, 1993. Dye destruction print, 40 x 30 in.

46 *Sing Sing #2*, 1992. Dye destruction print, 30 x 40 in.

47 *Prison Cell with Skylight*, 1993. Dye destruction print, 30 x 40 in.

48 *Georgian Jail Cages*, 1993. Dye destruction print, 40 x 30 in.

49 *Prison Typology in Nine Parts*, 1993. Waterless lithographs, 48 x 48 in.

50 *Cafeteria and Cell with Toilet*, 1993. Waterless lithographs, 22 1/4 x 37 1/4 in.

51 *Asylum*, 1994. Dye destruction print, 48 x 60 in.

52 *Tunnels*, 1995. Dye destruction print, 48 x 60 in.

53 *Toilets*, 1995. Dye destruction print, 48 x 60 in.

54 *Arcade*, 1995. Dye destruction print, 62 1/2 x 48 in.

55 *Apse*, 1996. Dye destruction print, 48 x 60 in.

56 *Cell with Rubble*, 1996. Dye destruction print, 48 x 60 in. *

57 *Nine Alcoves*, 1996. Dye destruction print, 48 x 48 in. *

58 *Arena*, 1996. Dye destruction print, 48 x 60 in. *

59 *Western Street*, 1985-86. Gelatin silver print, 30 x 40 in. *

60 *Panopticon #3*, 1993. Dye destruction print, 40 x 30 in. *

61 *Prison Cell with Toilet*, 1993. Dye destruction print, 40 x 30 in. *

62 *Mission Façade*, 1988. Gelatin silver print, 30 x 40 in. *

63 *A Barrel Vaulted Room*, 1994. Dye destruction print, 60 x 48 in.

* These plates are not in the exhibition tour of *Model Culture*.

ACKNOWLEDGEMENTS

ON BEHALF OF THE TRUSTEES AND STAFF of The Friends of Photography, I would like to thank the many individuals and institutions that made this publication, and the exhibition it accompanies, possible. Most importantly, the Lannan Foundation of Los Angeles provided generous support of the entire project from its inception and was in every respect an ideal sponsor. Foundation personnel were extremely helpful and sympathetic, especially in the project's crucial formative stages.

Throughout, this undertaking has been a collaboration with the artist, and James Casebere's willingness to participate has given the project its creative spark. He made himself available to the authors and editors, assisted in the process of selecting work, and allowed us open access to his interior artistic processes. Working with him has been an enlightening pleasure for me personally, and for all of us at The Friends of Photography.

Michael Klein and David Gray of the Michael Klein Gallery in New York were instrumental in helping make the exhibition and book possible, providing lists of artworks and constant encouragement along the way. In London, Nicholas Logsdail of Lisson Gallery was invaluable in supporting this publication, as were Salvatore Galliani and George Place of Galleria Galliani, Genoa. Tina Summerlin worked long and hard at the project's beginning stages in ways that shaped its ultimate form.

Maurice Berger has written an elegant, thought-provoking essay that opens major pathways for understanding the critical and aesthetic framework of Casebere's art. Michiko Toki of Toki Design has fashioned an equally elegant design for the book. On the staff of The Friends of Photography, Deputy Director Deborah Klochko oversaw the entire project; Exhibitions Coordinator Joanne K.H. Chan worked beyond the call of duty to bring the show together and to create its tour and catalog; Senior Editor Steven Jenkins guided the book to completion and provided an insightful interview with the artist; and Charlene Rule participated in editing and production. Danielle Gold, Amy Howorth, Amy Kweskin and Grace Loh also contributed in important ways to the book's final form.

Carla Emil and Rich Silverstein, Linda and Jon Gruber, and Tony and I'Lee Hooker provided important additional support to make this publication possible, as did Alitalia Airlines, Color 2000 and The New Lab, San Francisco. Paul Sack allowed the artist open access to his collection of architectural photography so that he could select works for a companion exhibition at the Ansel Adams Center for Photography. Without such enlightened participation by individuals and businesses, promulgating the work of important contemporary artists in photography would be even more difficult, if not impossible.

Finally, I would like to thank the many lenders who allowed us to borrow key works by the artist, including the Albright-Knox Art Gallery, Buffalo, the Brooklyn Museum, The Capital Group Companies, Inc., The Jewish Museum, New York, The Progressive Corporation, Cleveland, the Tampa Museum of Art, the Walker Art Center, Minneapolis, the Whitney Museum of American Art, New York, and Dr. Russell Albright, Dr. Joseph C. D'Amico, Beth Korein, Donald Porter and Wendy Knox-Leet, Dr. Mary J. Roman and Milton and Maxine Warshaw. Their generosity, together with the support of the Williams College Museum of Art and its director, Linda Shearer, has made it possible to tour the exhibition.

Andy Grundberg
Director, The Friends of Photography

THE FRIENDS OF PHOTOGRAPHY, founded in 1967 in Carmel, California, is a member-supported, privately and publicly funded educational organization that operates the Ansel Adams Center for Photography in San Francisco. The Friends of Photography's programs in publications, exhibitions, education and awards seek to present, analyze and interpret photography as the fundamental medium of contemporary visual experience, and serve as a forum for the intersection of images and ideas. Membership is open to all. The Ansel Adams Center is located at 250 Fourth Street, San Francisco CA 94103. For information, please call 415.495.7000 or fax 415.495.8517, or send e-mail to fopexed@aol.com.